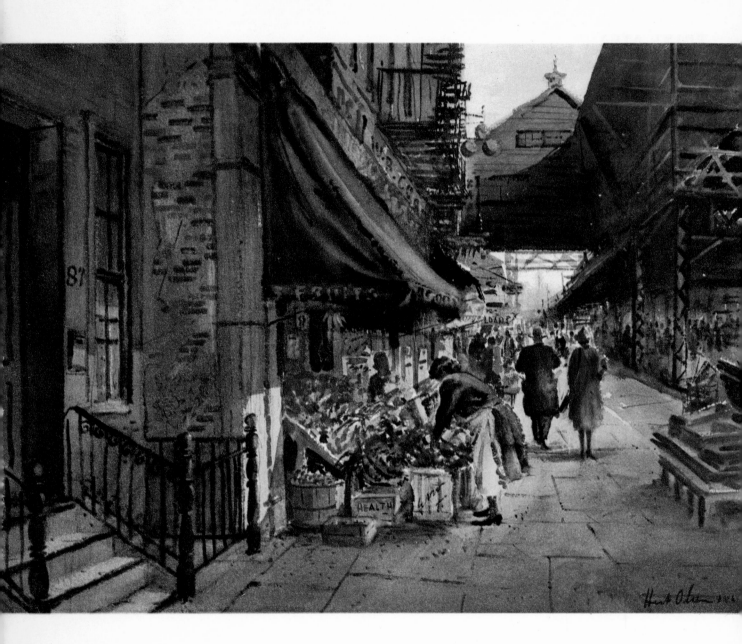

THIRD AVENUE

WATERCOLOR MADE EASY

Herb Olsen, A. N. A.

REINHOLD PUBLISHING CORPORATION—NEW YORK

REINHOLD PUBLISHING CORPORATION

all rights reserved
Library of Congress Catalog Card No. 55–6279

To my wife, Doris,
whose tireless efforts and inspirations
made this book possible

TABLE OF CONTENTS

COLOR PLATES

All photos by W. L. Christensen

THE THEME

In the past few years watercolor has assumed the importance in the art world it rightly deserves. Watercolor with its freshness and vitality has an appeal distinctly its own. Today the old style of watercolor painting, which was largely thin washes over pencil, has been so developed that in its place we now find paintings of a depth and permanency that previously could have been achieved only in other mediums.

In *Watercolor Made Easy* it is my desire to try to dissolve the aura of difficulty that has surrounded watercolor painting for so long and to demonstrate aids in helping to make it a medium not to be feared but one to be loved and thoroughly enjoyed. A solid plan is a requisite to any good painting. This means proper division of space; after this these areas must be broken up into the desired shapes. Much drawing can be done while painting, but a completed drawing before putting brush to paper is advisable for the inexperienced. No amount of painting can correct mistakes in composition when there has been no thought given to a plan.

In this book, simple step-by-step procedures demonstrate the development of a watercolor from the initial conception to the finished painting. Also shown are graphic solutions of problems which many artists find particularly troublesome. It is commonly thought that it is impossible to correct an error in watercolor. This is a mistaken idea; with practice and good materials, it is perfectly possible to make

certain corrections, additions, and even deletions. In "City Kids," below, I originally painted a red-and-white barber pole directly to the left of the iron fence. It was suggested by a friend that it might be a better picture without the pole. Upon thinking it over, I agreed and began the removal process by using clean warm water and a soft sponge, delicately patting the area until the pole disappeared, and then repainted the stones back into the picture. Can you locate the repainted area?

My aim in this book is to tell as clearly and concisely as possible how to make watercolor painting easier. It is not meant to be a literary treatise in which to express my views and theories of art. If it helps you and inspires you to paint, it will have fulfilled its purpose. Remember, no less a personage than Winslow Homer once told his art dealer, "You will see; in the future, I will live by my watercolor."

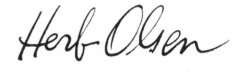

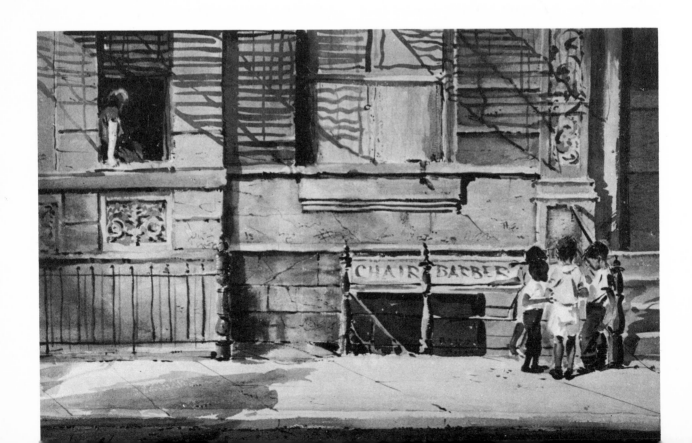

MATERIALS

My attitude toward materials may be summed up by paraphrasing the old adage that just as you can't be a good carpenter without good tools, so you can't be a good watercolorist without good materials.

Even the beginner, who must spoil and throw away a lot of paper, should not start off with too cheap a grade of paper. Adequate machine-made rag-content papers are available for *practice*. However, as soon as possible, the beginner should switch to a good handmade paper. Such paper not only takes paint better but shows up whiter at those times when the paper becomes an integral part of the design, such as when painting snow scenes.

It also pays to be consistent in the *grade* of paper you choose. This makes it possible to evaluate your work as you progress. After you've learned to achieve a certain effect on one grade of paper and find that it doesn't work on another grade, you'll understand the importance of this point. By using the same grade, you can, under ideal conditions, achieve the same effect rather consistently.

Paper designations, such as 300-pound rag, must puzzle many people. It is best explained by starting with the ABC's of paper measure, as follows: 1 quire is 25 sheets; 1 ream is 20 quires or 500 sheets. A ream of ordinary typewriter paper contains 500 sheets and weighs, at most, a few pounds. A ream of watercolor paper also contains 500 sheets, but the weight may vary from 72 pounds to 400 pounds, depending on the thickness of the paper.

In the beginning you may want to use a lightweight unmounted paper, say 72 pounds. However, you will soon discover that it will tend to buckle when heavy washes are applied. The resulting wrinkles can be most disconcerting when you are trying to paint reasonably straight objects such as telephone poles, fence posts, and piles. I have found the 300-pound weight to be nearly wrinkle-proof.

In choosing paper you must also consider its texture. Surfaces from very smooth to rough are available. Selection is usually based on the technique employed by the artist. I use the rough paper almost exclusively because I find it of great help in softening edges, creating textures, etc. I prefer the 300-pound d'Arches rough or the 300-pound AWS rough. The d'Arches has a slightly yellowish tint, whereas the AWS is pure white. Both are handmade and of the same high quality.

Sandpaper *is used chiefly for scratching off paint in areas where more white is needed.*

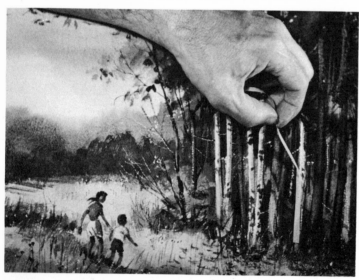

Masking tape *is used to cover those areas of a painting that you wish either to leave as white paper or to paint later on. Maskoid serves the same purpose for small areas (see page 58).*

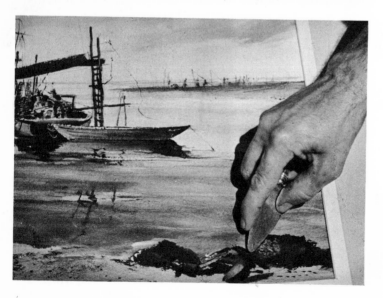

Butter knives *are very useful as tools and, because of their blunt edges, are particularly handy for scraping off paint softly for textural effects.*

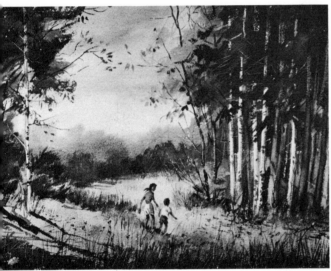

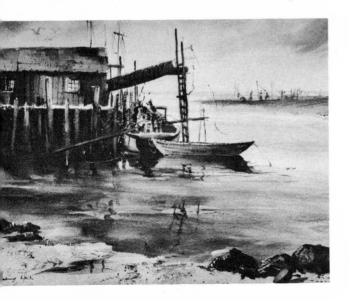

The handmade paper craft is a fascinating one and, to the artist, most important. D'Arches and AWS papers are made in Europe. The AWS paper I speak of is sponsored by the American Watercolor Society. It is being made for our Society in England and will be handled by the Stevens-Nelson Paper Corporation. The American Watercolor Society, which is now nearing a century of championing the cause of American watercolors, subjected this paper to the most exacting tests before accepting it. It is made in weights up to 400 pounds to the ream and bears the watermark AWS.

Although paper comes in various sizes, the one most commonly used is 22 inches by 30 inches and is known in the trade as "Imperial" and to artists as a full sheet. Another common size is the half sheet, which is 22 inches by 15 inches.

Although there are many colors of fine quality available, I find that for my work Rembrandt colors are the most satisfactory (see palette on page 15). I use the following watercolor brushes: 2½-inch second grade camel hair and 1-inch Grumbacher aquarelle which are flat; 1-inch, ½-inch and ¼-inch short-hair flat bristle brushes, made for oil painting; numbers 12, 8, 5, and 2 red sable Winsor & Newton or Grumbacher round watercolor brushes.

Additional equipment needed by the watercolorist are a soft cosmetic sponge (fine-textured and natural—not rubber); a water container (see page 22); paint rags; sandpaper; sketch pad; masking tape; hand mirror; a low sketching stool; kneaded and sand erasers; HB, 2B, and 6B pencils; drawing board; tube of rubber cement; Maskoid; paint-box; mat knife; and butter knife.

Much of the above equipment is demonstrated in use on pages 10 through 15. A 5-inch by 7-inch sketch pad is another useful adjunct to the sketching trip for thumbnail sketches preliminary to working on the main

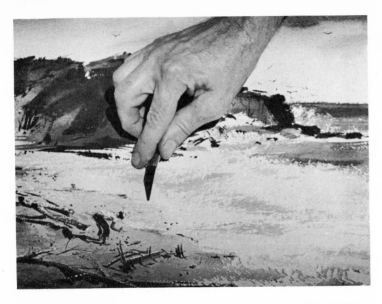

Mat knives *are used for nicking and scraping painted areas to bring out white accents.*

Cosmetic sponges *are used for wetting areas of the paper before brushwork and for deleting effects not wanted. I even paint with them sometimes.*

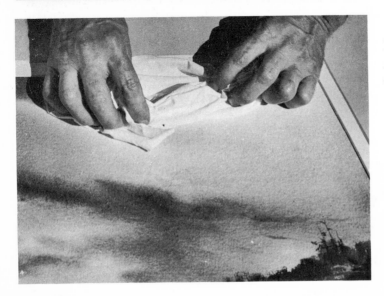

Paint rags, *like sponges, are necessary adjuncts to the painting trip and are used for wiping brushes, altering cloud effects, etc.*

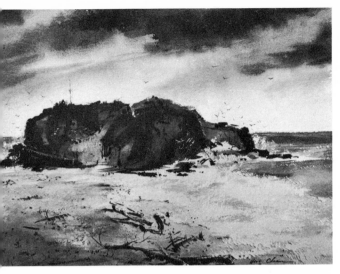

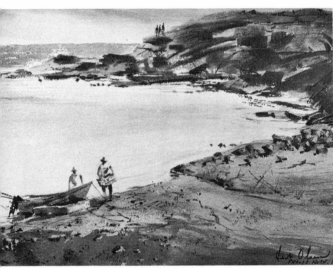

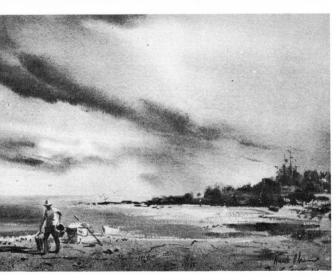

picture or for pictures to be finished back in the studio. This also serves as a record of the amount of work you have done during the year.

A hand mirror is of great use in looking at your pictures reversed. This aids you in seeing many things which are not immediately apparent when you look at the picture in its original position. It shows you how well your picture is balanced and how well it is tied together. It also doubles your distance, shows how the picture will look when hung on the wall, and helps you to find the best place to put your signature.

The low sketching stool is recommended because working is easier when sitting near the ground. Actually, I prefer to sketch or paint outdoors while in a kneeling position. You can use a watercolor easel if you like, but I think you will find my method easier, and it eliminates the extra equipment.

The kneaded eraser is useful because with it you can correct your pencil sketch without affecting the texture of the paper.

The glare of sunlight on white paper is perhaps the greatest problem in painting outdoors. Rarely will you find the point from which you want to paint conveniently shaded. Umbrellas are cumbersome and, with all other necessary equipment, a downright nuisance. I use polaroid sunglasses as a solution to the above problem because this glass has no adverse effect on color or values. Paintings I've done outdoors wearing polaroid glasses have reduced eye strain and are exactly the same as I would have done had I been able to work in a shaded spot. In a sense, polarized glasses are an *aid* to outdoor painting because they pull together light and dark values and simplify the masses. They can be purchased from any good optical house, but those who wear corrective glasses should have them made from their own prescriptions.

PALETTE

The organized planning of the palette is a great aid to competent painting. Too often the beginner fails to realize the necessity of instinctively knowing where a particular color lies on his palette. Just as a typist automatically reaches for his keys, so a painter should automatically reach for his colors.

Shown on the facing page is my palette (not necessarily the only arrangement) starting with the warm colors — yellow ochre, lemon yellow, cadmium yellow, cadmium orange, cadmium red, alizarin crimson; then the earth colors—Indian red, sepia, umber, burnt sienna; then to the cold colors — French ultramarine blue, cobalt blue, Antwerp blue, Payne's gray, mauve; and then the greens—emerald green, Hooker's green No. 2, Rembrandt green; and finally black. There are additional colors, such as orange, oxide of chromium, sap green, and vermilion, which are sometimes used to achieve certain effects, but this suggested palette should be sufficient. Place colors around the edge of palette and leave the center free for mixing. For a palette I use a 19 by 13-inch porcelain butcher's tray.

I would strongly urge you not to be too sparing with your pigments as you prepare your palette; use about half a tube of each color. Nothing is more annoying when laying in a wash than to find you have no more color. By the time you squeeze out more color, the area being painted may have dried, causing serious trouble. If a color has been lying on the palette for some time between painting sessions and shows signs of cracking, a drop of glycerine will soften it.

I do not want to ignore pan colors, but I personally do not recommend them because in a pan-type box the mixing area is too limited and pans placed on the palette are unsteady.

All good brands of watercolor paints today are permanent with the possible exception of alizarin crimson, which is a coal-tar product. It should be used very sparingly. Do not make the mistake, even if you are a beginner, of buying cheap color. It is no economy because you use more of it, there is no guarantee of permanency, and the colors are not true. Get accustomed to good color and what it can do for you.

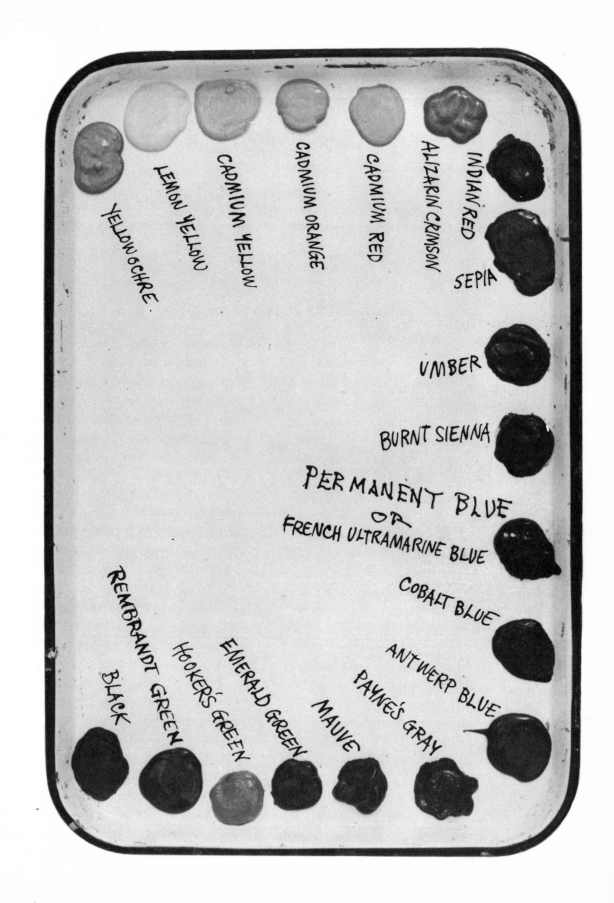

YELLOW OCHRE.

LEMON YELLOW

CADMIUM YELLOW

CADMIUM ORANGE

CADMIUM RED

ALIZARIN CRIMSON

INDIAN RED

SEPIA

UMBER

BURNT SIENNA

PERMANENT BLUE
OR
FRENCH ULTRAMARINE BLUE

COBALT BLUE

ANTWERP BLUE

PAYNE'S GRAY

MAUVE

EMERALD GREEN

HOOKER'S GREEN

REMBRANDT GREEN

BLACK

15

IMPORTANCE OF EFFECTIVE COMPOSITION

The structure of a painting should attract the eye to its central theme, which is called its center of interest. If it does this, the painting begins, at least, to be a good composition. But the center of interest must be supported by other elements in the painting. In the case of the drawings on the facing page, the preliminary sketch, named Gaspé, has as its center of interest the little group of houses in the lower foreground. Supporting elements include the smaller houses on the beach beyond, the headland in the background, and the water itself. You have undoubtedly seen carelessly composed pictures which have so many conflicting elements, so many distracting side-issues, that a focal point has been completely lost. Supporting elements must never detract from the central theme. Study of a random group of snapshots will probably show you just how important side-issues and their proper placement can be. The person who snaps his camera to record a beach party, for example, is not usually concerned with anything but the person or persons whose picture he is "taking." The center of interest is so important that supporting elements are completely forgotten. Such subjects, as a result, may have telegraph poles growing out of their heads or may be shown with the feet in the foreground of such tremendous size that they compete for attention with the center of interest itself.

It is not the purpose of this book to delve deeply into the subject of composition. The aspiring student of watercolor must, as he progresses, gradually become aware of such essentials as proportion, rhythm, unity, balance, contrast, etc.

It is important, however, that the artist, before he starts a picture, be completely sold on the importance of its subject matter. If he lacks this enthusiasm, his interest will flag, and the final result will be one of hopeless mediocrity. Therefore, pick a subject that you are strongly drawn to and start by thinking about it in terms of pattern so that your areas will be well and interestingly divided. Next, decide on your eye level; this horizontal determines the horizon line in your painting. (This is more fully explained on page 18.) Having decided what to paint, you must next decide what interests you most, foreground or background. The next step is to view your subject in abstract terms, breaking down the component parts of your design and placing the elements in their proper relation to each other (see page 29).

The next step is a prerequisite to all painting—a good drawing. If you cannot draw, your case is not hopeless, but you must learn to draw. You will find, too, that your watercolors improve as your ability to draw increases (see page 93).

The accompanying sketches are included to help you see the movement of a composition. Using the letter "S" as a basic form, I produced a coastal sketch. In the letter "X" I have presented a city scene. Try this exercise yourself and see how many pictures you can develop from the use of different letters. For instance, the letter "O" has possibilities for a racetrack, a ballet dancer, and so on. Other letters have possibilities too.

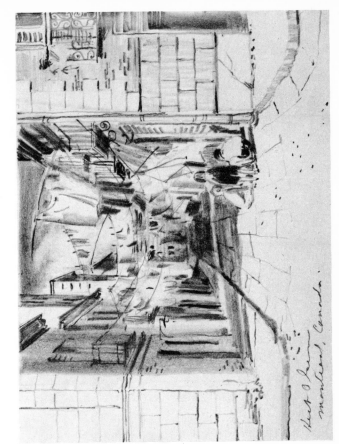

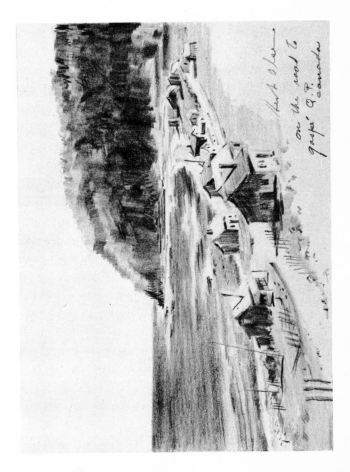

HORIZON LINE AND EYE LEVEL

The horizon line lured early navigators to the discovery that the earth is round. It drew them onward and onward until inevitably they arrived at the place from which they had started. And the horizon line was still in front of them!

I find that students learn much about composition and the simpler facts about perspective when they discover that the horizon line is always at their own eye level. On page 22 you will find a sketch which shows how to find the horizon line by holding a pencil at eye level. I also recommend that you discover the magic of the horizon line by holding the pencil at eye level first in a standing position, then in a squatting position, then in a sitting position, and finally lying prone.

The importance of the horizon line is well demonstrated in the paintings on the facing page. Actually, what is really one picture has been turned into two distinct pictures by a mere shifting of the placement of this line. In the top picture the horizon line is low and the foreground shallow, making the sky the predominating motif and therefore the center of interest. In the bottom picture the same horizon line is placed high and most of the sky is eliminated, making the foreground and the figure group the dominant note of interest. If you were to imagine everything from the middle of the tree down in the top picture as having been eliminated, it becomes perfectly clear that this is one picture. Can you say that one picture is better than the other? I would say it is just a question of the painter's emphasis and graphic intuition.

In your own work the decision about what to include above and below the horizon line may, at first, present a perplexing choice. However, as you continue to draw and paint, your knowledge of what makes a good composition will increase and you will be able to decide on the placement of the horizon line almost instinctively. You may even find more than one picture, as I happen to have done here.

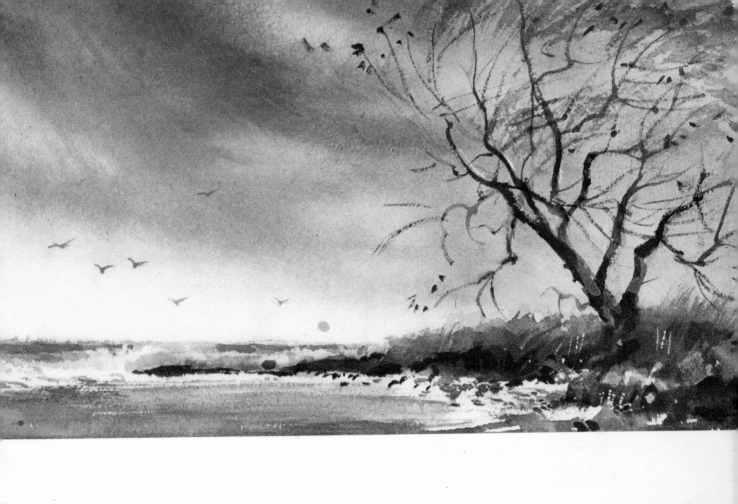

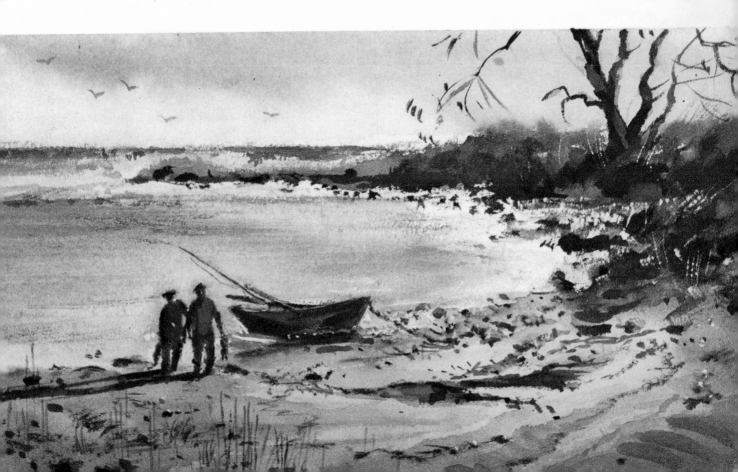

PROUTS NECK

PLANNING YOUR PICTURE

One of the lessons that experience in making thumbnail sketches (see page 30) will teach you is which way to put your picture on a sheet of paper. As mentioned in the materials section (see page 9), watercolor paper comes in sheets (22 inches by 30 inches) or half sheets (22 inches by 15 inches) because the full sheet, called "Imperial," is standard equipment. Constant use of these sizes can be habit forming, leading the unwary to the conclusion that his pictures must be painted within the *limits* of those dimensions. This kind of thinking should be avoided. If you feel that your subject calls for less than a full sheet or more than a half-sheet, by all means utilize the size you feel is needed to give your picture the proper area of expression. Be careful,

too, not to make the mistake of thinking that your picture should be painted the horizontal way of the paper because it looks more conventional that way. The illustrations on pages 23 and 24 prove that vertical pictures and horizontal pictures that are not the proportion of a standard sheet may be just as successful as those that are. Also refer to pages 35, 56, and 91.

You may occasionally find that a picture that does not please you when it is finished may be saved by overlaying long narrow mats or square mats of different openings until you find a more satisfactory arrangement of elements.

On page 22 you will find a very simple lesson in perspective. It is helpful in planning your picture to understand, at least, the

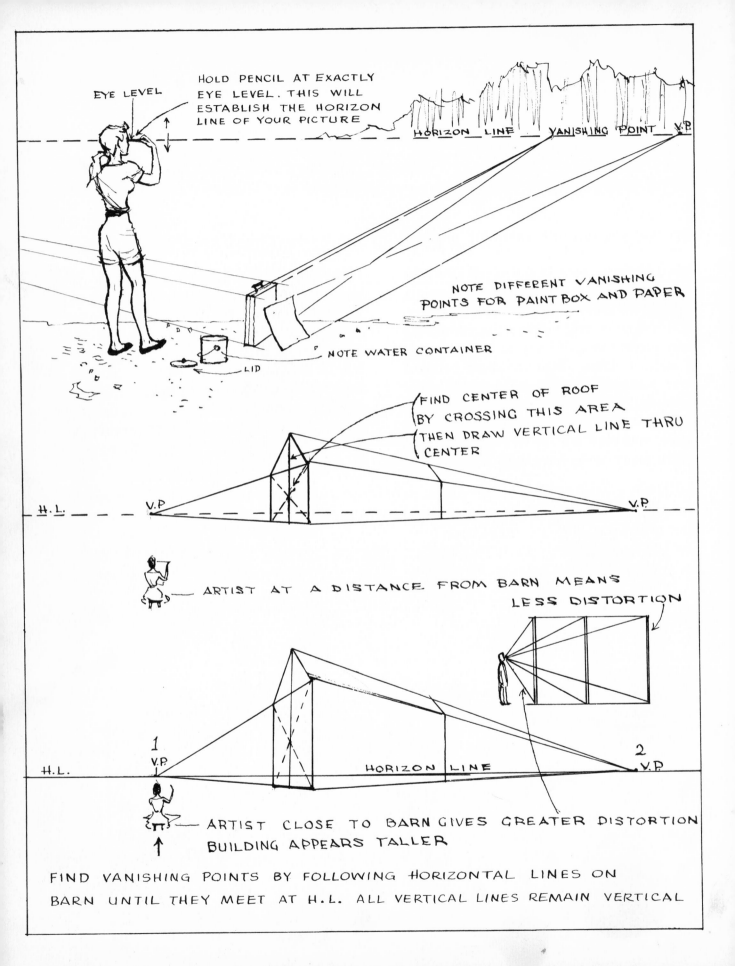

fact that you establish vanishing points at either end of your horizon line. All the elements of the picture, if abstracted (see page 85) would lead to one of those two points, either from above or below the horizon line. It is not necessary, however, in composing your picture to go to any such extreme. It is useful to know about vanishing points if your composition includes a building or buildings. As you progress, you may wish to learn more about perspective or, then again, you may not. It is a subject about which many books have been written. It is also a subject which has developed considerable controversy. Some artists wish it had never been discovered, large numbers of well-known artists have learned to use it properly or to violate its principles almost intuitively to achieve some effect, while another large body of artists would feel helpless if they did not study the mechanical aspects of it in planning all their drawings. A good recent book which does much to clarify the use and misuse of perspective is *How to Use Creative Perspective* by Ernest W. Watson (Reinhold).

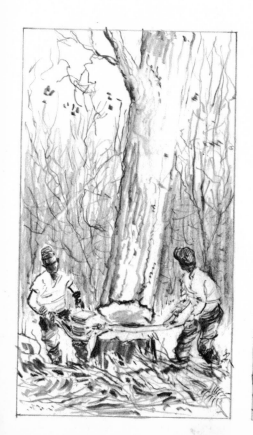

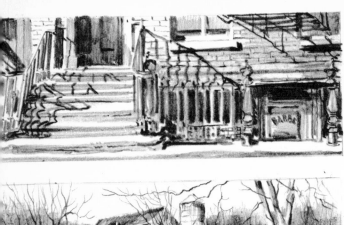

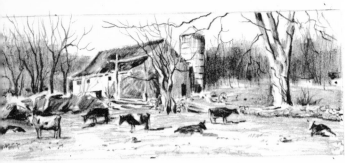

The two pictures at left are examples of offsize horizontal pictures. The farm scene with its free panoramic openness is in direct contrast to the tight, constrained city "sidewalk-scape" complete with brownstone, ironwork, barber shop with basement entrance. In contrast to these, on the bottom is the full sheet (22 in. x 30 in.) which is the conventional size and shape. Is one better than the other? Note in the cascade how again Maskoid was used to retain desired white areas (see page 58).

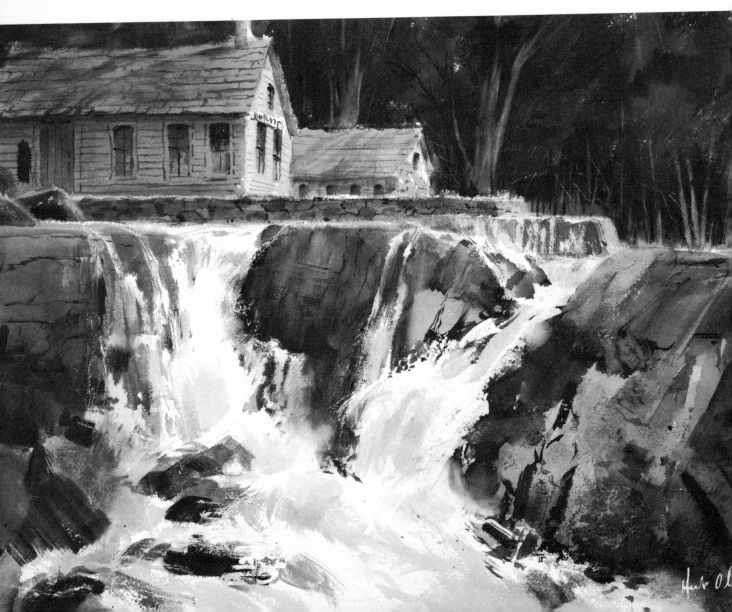

DAUBS

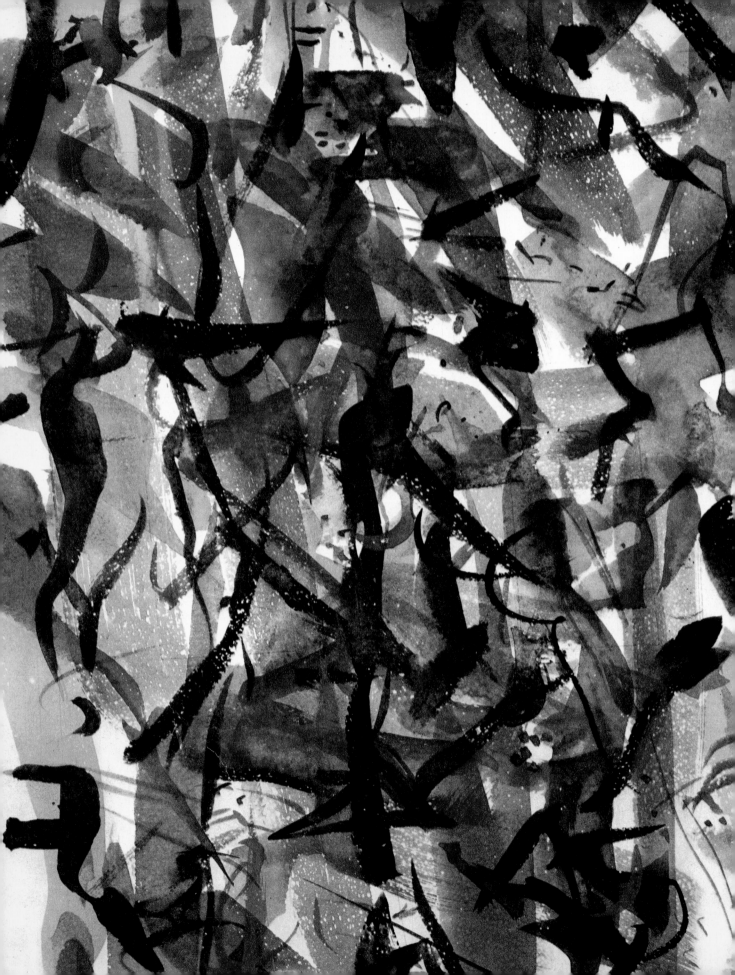

FINDING COMPOSITIONS IN ABSTRACTIONS

Reproduced on the left-hand page is a painting which looks like an abstraction. It is the work of two people who had never painted a picture in their lives. I gave each of them a number 2, a number 8, and a one-inch wash brush and told them to throw discretion to the winds and give their artistic fancies free rein.

In the back of this book is a heavy paper view-finder or mask. Note the many different pictorial compositions you can find through the cutout by moving the view-finder slowly around the surface of the painting. In doing this, half close your eyes so that you can more easily find images that

will suggest a picture to you. This exercise will stimulate your imagination as well as teach you to find pictures where you may think that none exist. This same approach can be applied to the pictures that one seeks in nature. Don't look for the obvious; it is not necessary to travel miles in search of pictures that somewhere (you hope) nature has already arranged for your convenience. There is probably a better one in your own backyard.

Abstractions have a highly practical basic value and, when used discreetly and intelligently, they can be of real assistance to any artist.

the abstract applied to composition

My views about abstractions can be stated quite simply in terms of composition and design. Specifically, I use abstractions during the structure, the build-up, of a painting. They are used, principally, to divide areas into effective components of the design. I could, of course, paint the picture in that state but, to me, it would be an incomplete statement, somewhat like the framework of a building.

Abstractions, as pictorial art, are, in the hands of competent and experienced craftsmen, works of tremendous dramatic power. However, to the inexperienced amateur or student, abstractions are apt to be siren calls luring them away from the discipline of first principles and basic training. Learn the fundamentals first; then strike out wherever your fancy may lead you.

The practical application of abstractions to conventional design will be of far more value to you than any attempt on your part to express yourself in abstract pictorial terms. These are certain to be meaningless until you have learned something about the forms upon which they are based.

On the facing page I have demonstrated my use of abstract forms to pull a picture together. You will find, if you adhere to this formula, that it will help solve many problems of balance and placement in the basic design of a painting.

Mr. Jay Datus, a well-known artist of Phoenix, has expressed the differences in philosophy between the conservative and the modernist thus:

the modern point of view

The modernist feels that the psychological impact of line, color, mass, and other abstract elements of art is enough to carry his artistic message. While there are many different philosophies among modernists, they generally agree in wishing to be unrestricted by naturalism. Their sincere wish is that the public will approach their work open-mindedly and free of a preconception based only on realism.

the conservative point of view

The traditional painter uses line, color, mass, and other abstract elements to express the emotional message of his art, but he feels this is not enough. This is only his framework, upon which he builds naturalistic form which also carries his ideas. He does not see nature as restrictive, but as a discipline within which artists of his tradition have grown great. He sees nature as a teacher of the ever deepening beauties of life.

This scene was drawn exactly as it appeared. It is a rural Connecticut landscape with interesting possibilities. However, changes must be made in order to make it a sound piece of work. At first glance, the picture seems pleasing, but on closer examination you will note that each tree follows the perpendicular lines of the buildings, the road starts in the center of the picture, the fence is static, and the limbs of the trees all have the same direction; the painting does not establish a mood.

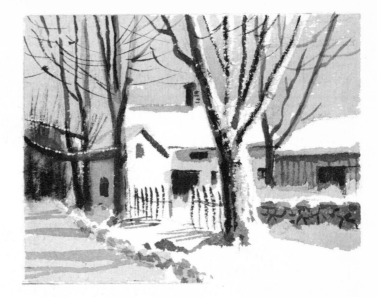

This is an abstract of the above picture. It is broken down in terms of composition and design. Note how the space is divided using only large forms and no identical sized areas. Also note how the branches are used to divide the spaces interestingly. This is one way to make a better picture.

Here is the result of the abstract re-alignment of space. The trees, as you can see, are placed in such a manner that they frame the buildings. The new arrangement of the road gives the picture a base, the fence is more interestingly broken up, and the whole picture comes back to realism through the strength of the abstract.

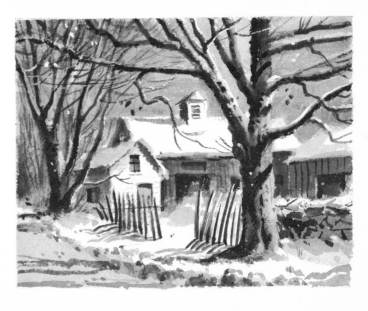

THUMBNAIL SKETCHES

As a study of page 29 indicates, one way to start a picture is to abstract the various elements of the composition. A second way, once you have decided upon your subject, is to make several thumbnail sketches, using both perpendicular and horizontal shapes. In these small sketches you can experiment with the composition and design that your picture eventually will take. Never mind details in these sketches; concentrate instead on the large forms, masses, or areas of your picture-to-be. Then, as soon as the composition has been established to your satisfaction, you are ready to transfer the picture to a full or half sheet (22 inches by 30 inches, or 22 inches by 15 inches).

In making these sketches, be sure that their proportions are in the correct ratio to the half and full sheets. For example, a thumbnail sketch could be 3¾ inches by 5½ inches, or one-quarter the size of a half sheet. Divide the full sheet size by four in order to get the proportion for that particular size. If you fail to do this, your thumbnail will be completely out of proportion to the full and half sheet sizes. It is for this reason, as well as for reasons of economical framing, that I advocate standard sizes while you are learning the watercolor medium.

Above all, don't take the word "thumbnail" too literally and make your sketches too small. The practice of making thumbnail sketches is advisable whether one is a beginner or a professional. In either case, mistakes will be made and it is better to make them in a preliminary sketch than in your larger working areas.

Below are three alternate thumbnail compositions. Note the photograph at top of next page: it shows you the liberties I have taken in these sketches. Use photographs as a basic plan and then make your own compositions.

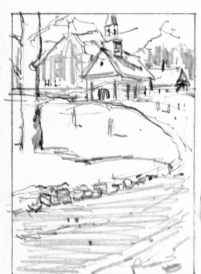
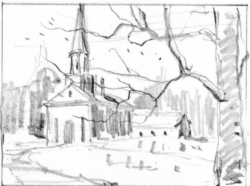
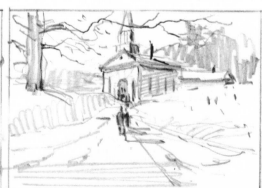

The photograph is of a scene which you might have selected as a subject for one of your pictures. Having done so, you are now confronted with the problem of composition, of moving objects around to form an interesting pattern or of changing the horizon line to feature either foreground or background.

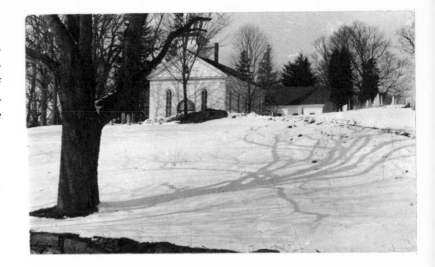

Here is how it is done. Move rock from in front of church to the left side. Make church larger and include more of sky and steeple by dropping your horizon line. Eliminate stone fence in the foreground and redesign tree and road. Road now leads the eye from lower left-hand corner of picture directly to church— the center of interest.

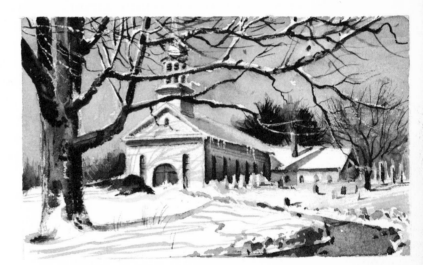

Here is another version of the same scene. In this one, we raise the horizon line in the picture in order to include all of the fence in our foreground, with the road still leading to the church as the focal point of the picture. We also include a vista of the background hills giving a sense of depth and distance to the painting. You can see how many possibilities a single picture can have, and how useful the thumbnail sketches are.

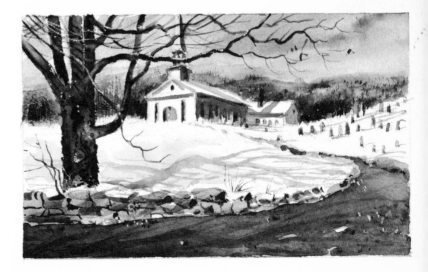

PAINTING THE FIGURE IN WATERCOLOR

The figure is included in this book for the benefit of those readers who have studied in life classes and who have had some basic training in figure drawing and anatomy. Figure painting is *not* for the beginner. However, those who lack the required experience may find in this section of the book enough stimulation to arouse an interest in drawing the figure.

As with every picture, we start with composition and placement of the subject. What will be the most interesting pose, the most striking? Should we use a full-figure or a half-figure? Should the figure be standing or reclining? Would a front, side, rear, or three-quarters view be most effective? If you are working from a model, you are now faced with the active problem of creating your composition, background, lighting, arrangement of accessory objects, etc. In landscape painting, nature conveniently provides all of the props, which you can paint as is or re-arrange. But in painting the figure, the entire arrangement and structure of the

picture is up to you. You are completely on your own.

As can be seen in the drawings shown on the opposite page, I arrived at the composition after making several thumbnail sketches. I felt that the final arrangement was a provocative pose and that night light would add to the atmosphere or mood. In sketch 1, I started with the triangular motif for proportionate division of space and for a strong design. As is commonly known, the triangle is the most powerful of all abstract forms. Sketches 2 and 3 as well as the small-figure action sketches are possible alternates to the first pose. Sketch 4 shows the results of a process of elimination. Here the composition has been simplified to accent the figure.

When I decided on the final pose, I very carefully drew the figure, accentuating the rhythm of the torso and the arms, with the legs remaining fixed. The background was drawn in last, with the same careful attention to details.

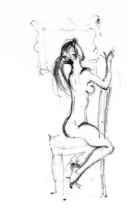

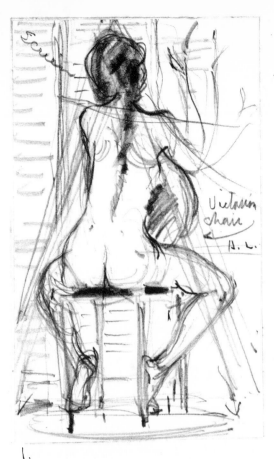

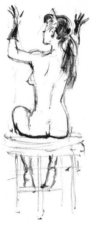

scene

Victorian
chair
A. L.

1.

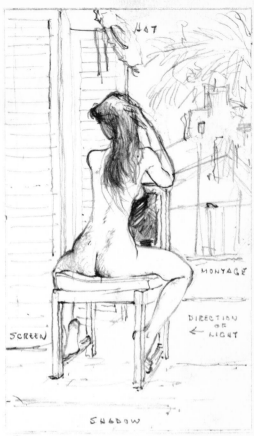

HOT

SCREEN

MONTAGE

DIRECTION
OF
← LIGHT

SHADOW

2.

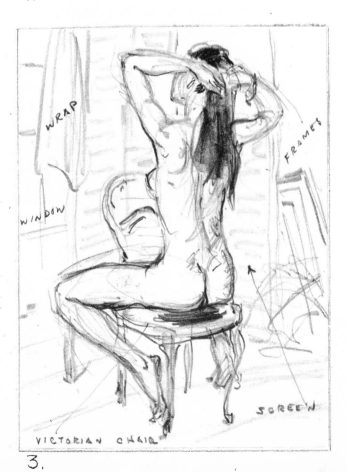

WRAP

FRAMES

WINDOW

SCREEN

VICTORIAN CHAIR

3.

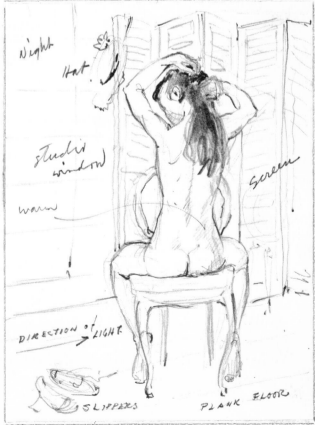

Night

Hat!

studio
window

warm

Screen

DIRECTION of LIGHT

SLIPPERS

PLANK FLOOR

4.

LILI

In painting any watercolor, I paint from light to dark. I work this way in painting a figure because it is difficult to recapture the light areas once the dark tones have been painted. Since I do not recommend the use of opaque white pigment, all white areas must be carefully planned.

When starting to paint, lay in the large areas first — such as background, floor, screen. Before finishing these areas, start painting the figure in light tones. However, the background must be dry before this is done. When the paint on the figure is semi-dry, paint in the large shadow areas in middle tones, carefully following the construction of the figure. Then add the darker tones in the spine, right side of back, and buttocks. After the figure is completely painted, soften the edges on the light side with a one-quarter inch oil bristle brush. When complete, do the background.

After the background has been painted, take a final wash of ultramarine blue, cadmium orange, and cadmium red and wash over the entire background to soften any hard edges. The same thing can be done over the figure in warm colors if the edges appear hard. The colors used in the figure are: Indian red, cadmium red, burnt sienna, yellow ochre, sepia, Hooker's green, and black.

In my painting of the figure, here is the actual sequence of color application. I first laid on a very light wash of yellow ochre. While this was still wet, I used Hooker's green, Indian red, and sepia in the shadow area; in the buttock area I added a touch of alizarin crimson to these colors. After this application and while the picture was damp rather than wet, I deepened the values, using the same mixture of colors. Then, after the picture was dry, I accentuated the spine by using my bristle brush to lighten the area indicated. Colors in the hair are black, ultramarine blue, mauve, and a touch of burnt sienna. In the feet I used the same mixture as in the figure only I used slightly more alizarin crimson. The figure was painted on a 300-pound rough rag paper.

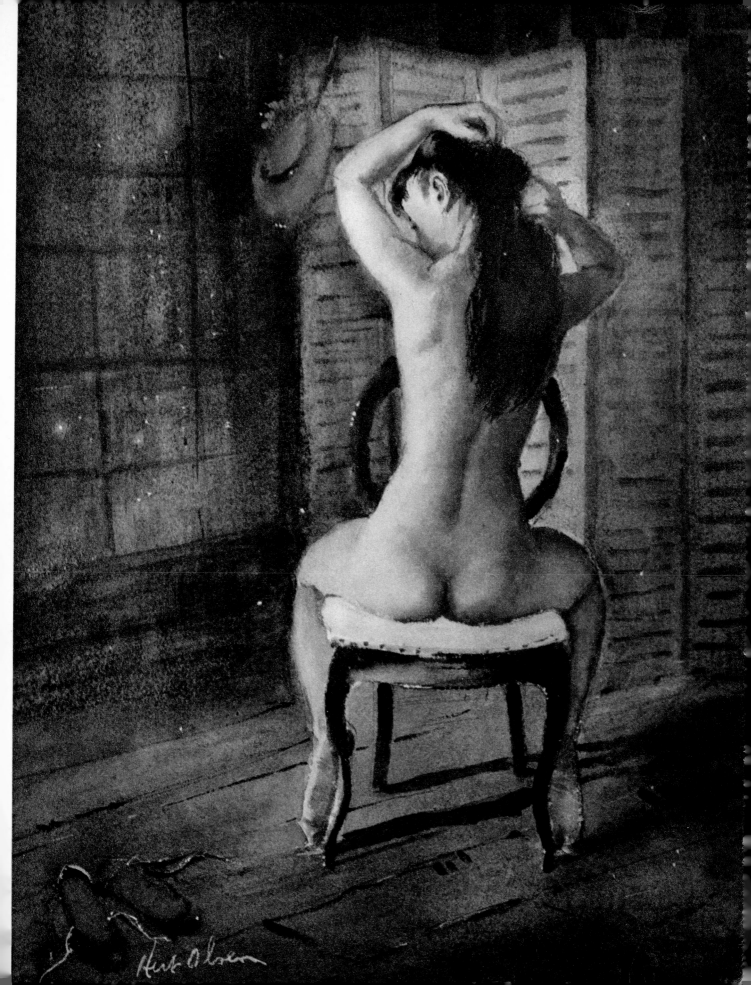

LILI

THE SINGLE-LINE FIGURE

The use of the single line figure is as old as the Hieroglyphic Age, and yet in modern day art this form of expression is still ageless and useful. To get the "feel" of drawing a figure in every possible action, make literally hundreds of these one-dimensional drawings and don't think of it as a chore. This can be a lot of fun.

With these primitive indications you can portray glee, dejection, sorrow, defiance and actions of all kinds. When you have the framework and action desired, dress the figure up, starting with your basic line. See the figures below. The beginner would be wise to keep the figure small to avoid excessive detail.

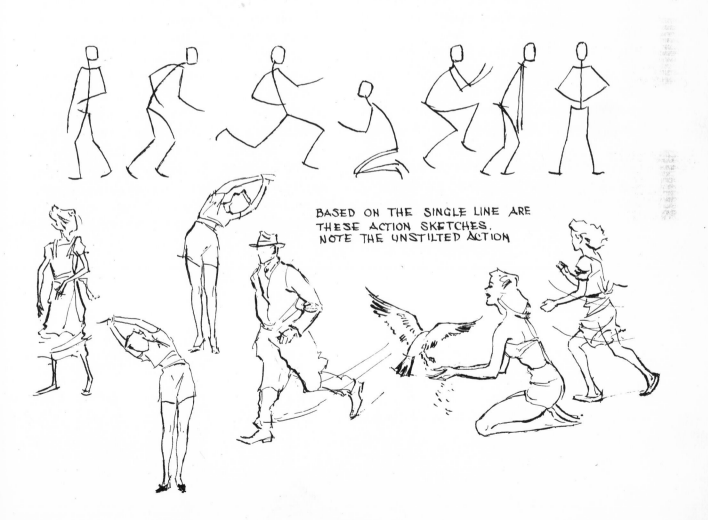

BASED ON THE SINGLE LINE ARE
THESE ACTION SKETCHES.
NOTE THE UNSTILTED ACTION

WRIST AND ARM EXERCISES

Opposite, the figure is shown seated, standing, and prone. In the seated figure we start with a single line to determine action and proportion. Note the use of the triangle to give rhythm and to aid in the structure of the entire figure without the use of a model.

Try several figure sketches in different positions and observe how the use of the triangle helps your drawing. This method is especially good when working from life because it will help give your drawing movement, action, and grace. You will note that in drawing the triangle you will be using wrist motion almost exclusively. Working with the wrist is good for getting detail. However, for freedom and boldness

in drawing, the circle is a much better form. In drawing the circle, make a conscious effort to move your entire arm, not just your hand. Practise in drawing the single line figure (see page 37) is an aid in learning rhythm and proportion. The final sketches, shown at the right, use both wrist and arm motion and therefore both the triangular and the circular figures should be practised.

Below are simplified illustrations, showing the use of the triangle and the circle in constructing the human figure. The line and circle at left shows that the figure is divided in half. By adding to this vertical, the figure is broken up into its abstract form. I drew these with a quill pen on smooth hard-surfaced paper.

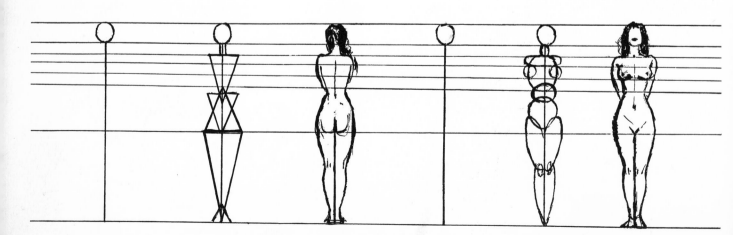

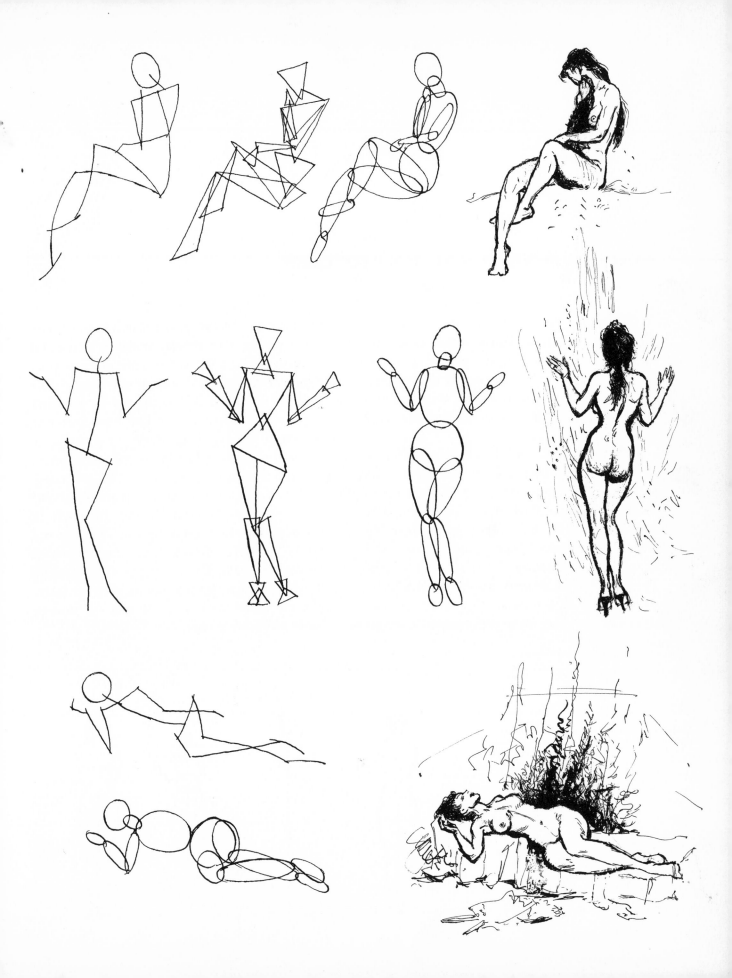

step 1. *The head*

step 2. *The torso*

THE SIX-STEP FIGURE

Your landscapes and other outdoor pictures may look lonely without figures. Here is a very simple way to add figures to your paintings even if you don't understand the first thing about anatomy. It might be called the six-stroke figure.

Use warm and cold colors, experimenting until you are satisfied with the result. See small figures on page 45 for color ideas. Figures will be more successful if you do not allow any color to dry during the painting operation. In other words, let the colors run together; this will provide a spontaneous result.

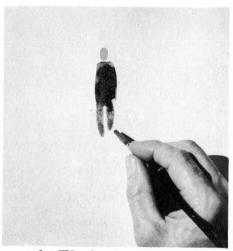

step 3. *The legs or pants*

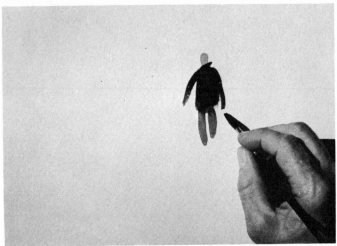

step 4. *The arms (and an inadvertent collar)*

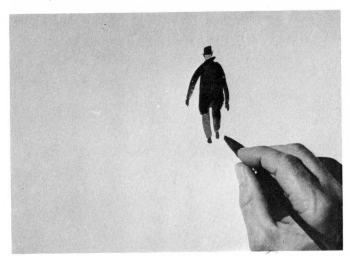

step 5. *Hands, feet, and hat*

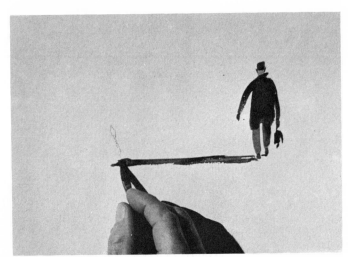

step 6. *Attaché case and shadow*

PEOPLING A LANDSCAPE

On pages 40 and 41 we see what looks like a commuter, complete with bowler hat and attaché case. Here I have equipped the same character with a wool cap and gun (or maybe it's a Geiger counter), and set him walking down the road. It is interesting to notice how different the scene is in the bottom picture without him. My purpose in showing the two pictures is to contrast the effects rather than to demonstrate that one is better than the other.

Notice, too, that in the picture in which I have included the figure, I have lightened the sky and lowered the horizon line. This tends to make the figure appear larger than it really is. If the horizon line were placed high, the same size figure would have been dwarfed by the immensity of the landscape.

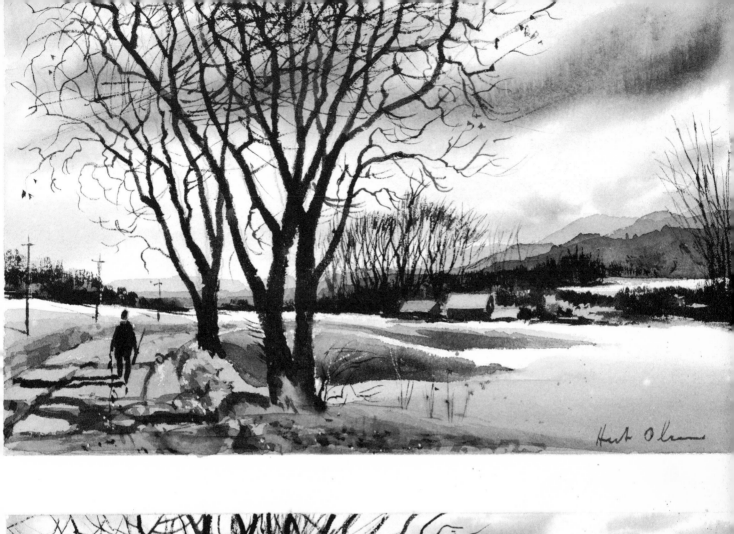

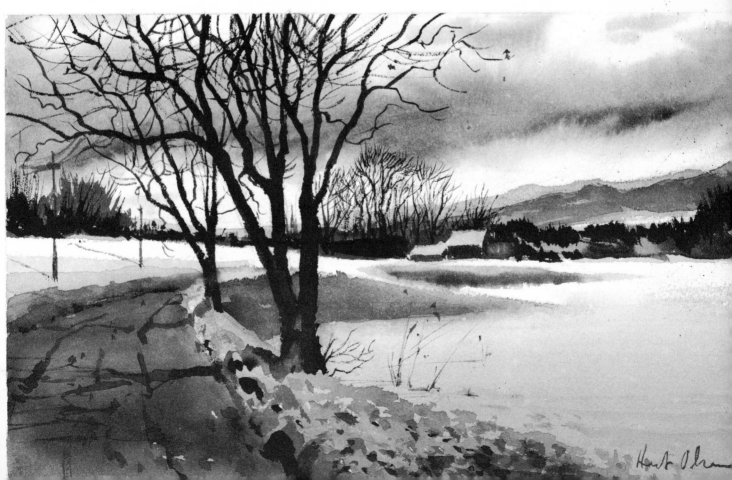

NO SKATING

This scene was observed in a small Connecticut resort town. It struck me immediately, and I could hardly wait to translate it into a painting. The awkwardness of the children and their disappointment in not being able to skate established the mood.

This painting was carefully drawn in pencil before final rendition in color. It is obvious that the figures in this painting were not done with six strokes like the little sketches below. Each one required several pencil drawings before completion. Such large, complicated figures must be drawn carefully after establishing the poses. A demonstration of my method of figure painting is given on pages 32–35.

SMALL FIGURES

The small figures at the bottom of the facing page were executed in the same way as the little man in the sequence demonstration on pages 40 and 41. In this case, however, I show a considerable number of figures in different poses in order to explain more clearly the effectiveness, speed, action, and freshness of this method of figure representation, which is so vital to watercolor painting.

Before putting the actual figure in your painting, make several practice attempts on scraps of the *same kind of paper* to get yourself into the swing of it. Do it in the same spirit in which a golfer takes a couple of trial swings before actually hitting the ball. Then when you put your figure in the actual painting, you'll do it boldly. You can't be afraid and be a good watercolorist.

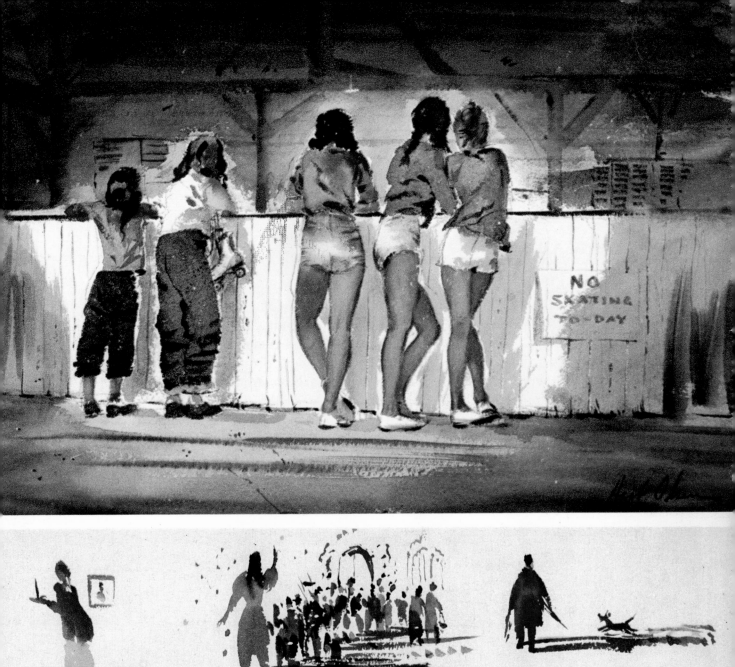

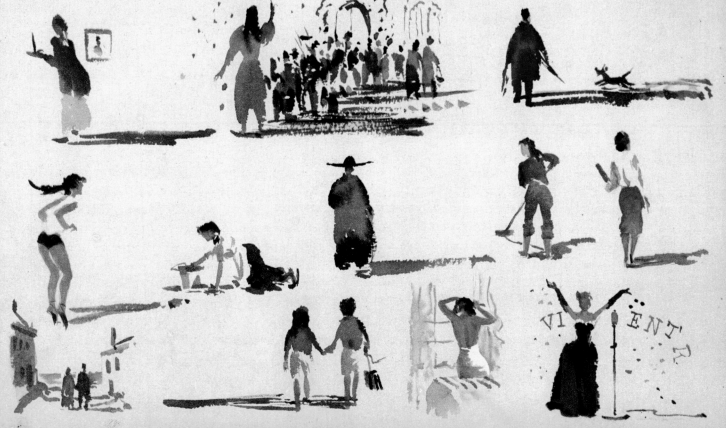

NO SKATING

COLOR

Unlike some teachers of watercolor, I advise students to start painting as soon as a satisfactory drawing is completed. So let's start right in with a simple explanation of value and color. Value, according to Webster, is "the relation of one part or detail in a picture to another with respect to lightness and darkness." You will see value sketches in black and white throughout this book. The primary colors of the painter's palette are red, yellow, and blue. When these three are mixed in pairs, we get orange, green, and purple.

To learn as much as possible about color, take each color in turn and play with it. See how alizarin becomes pink when water is added and how it becomes dusty rose when you add various shades of gray. Then experiment with various mixtures. You'll want to make copious notes as you go along with these experiments. They will be invaluable references later on, and unless the notes are on paper they may be forgotten.

Perhaps the easiest way to think of color is to divide your pigments into two general classifications—warm and cool. Refer to my own palette (page 15) for a visual explanation of this arrangement. The intermediate, borderline group between warm and cool can be slanted either way by the addition of a warm or cool color; this group is useful for such elusive color effects as weather-beaten barns, dirt roads, etc. However, do not concern yourself with these until you have assimilated the essentials, the elementary principles of color. To fix the warm and cool divisions in your mind, think of the hot, sultry colors of the tropics—the dazzling reds, magentas, yellows, oranges, purples—and compare them with the austere, cool, almost bleak colors of such northern regions as New England; think of the brooding grays, glacial blues, icy greens, and of the effect that these colors have even upon the personalities and temperaments of the inhabitants of those climes.

Think also of the emotional impact of color: how color determines the mood of a picture, how color can denote joyousness, gayety, and laughter, or how it can be stark, ominous, and foreboding. A wide, almost limitless range of effects can be achieved with the colors I use.

Since all paint manufacturers have their own pet names for many of their colors (such as robin's egg blue or sea green), I have used the names and brands of colors I actually use in order to avoid confusion (see page 14). However, once you have grasped the fundamentals, strike out on your own because every individual can develop his own sense of color. For example, a group of well-known painters worked simultaneously from the same model. When the paintings were finished, each artist showed a different color concept in his work, but each painting, viewed individually, was a true portrayal of the sitter. Despite the variations in each artist's color, all of the values in the paintings were properly related.

Another matter I would like to impress on your mind is that there can be happy, almost providential, accidents of color. If you make an unintentional brush stroke or drop some color where it doesn't belong, the effect may be well worth while keeping in the picture. Don't be in a hurry to delete such a mistake unless it actually harms the work.

There are really no set formulas to restrict or inhibit your creative urge. So let yourself go!

WATERFALL

In painting a waterfall, most people mistakenly believe that all the action is in the cascade itself because of the speed, motion, and general disturbance caused by the onrush of water. This is not so. The quiet action which takes place before the drop and the turbulence that occurs after the drop are the two essential factors in making a waterfall realistic. One needs the other in order to make a convincing picture.

On the opposite page, I have shown a small river fall to illustrate this principle and suggest you try it yourself. I have carefully indicated the colors to be used, but keep in mind at all times that the picture must be in value. See definition of value on page 47. Use the painting above the plan for your values.

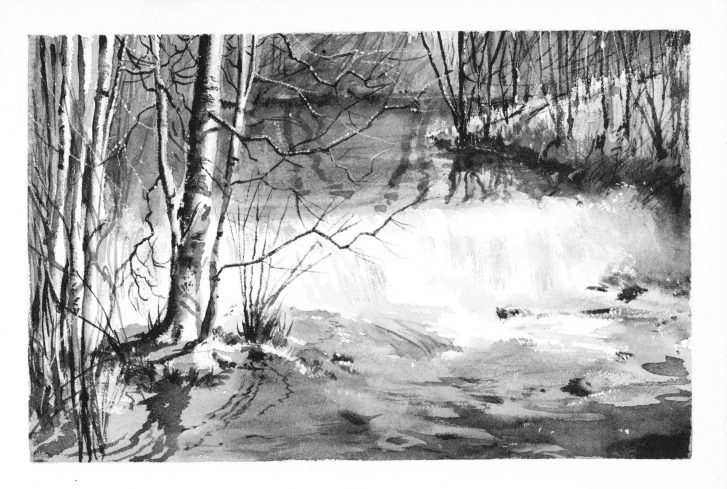

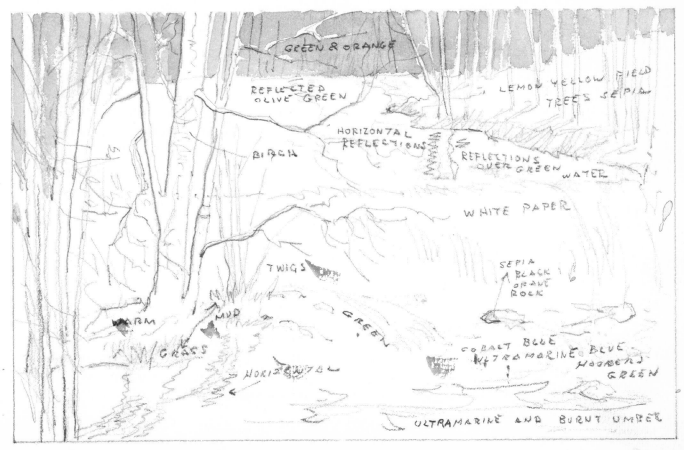

GREEN & ORANGE

REFLECTED
OLIVE GREEN

LEMON YELLOW FIELD
TREES SEPIA

HORIZONTAL
REFLECTIONS

BIRCH

REFLECTIONS
OVER GREEN WATER

WHITE PAPER

TWIGS

SEPIA
BLACK &
ORANGE
ROCK

WARM

MUD

GREEN

GRASS

COBALT BLUE
ULTRAMARINE BLUE
HOOKERS
GREEN

HORIZONTAL

ULTRAMARINE AND BURNT UMBER

FOG AND RAIN

In painting fog, you will note that objects very near you—because of the softness of the fog and mist—have a tendency to appear quite sharp. Remember, too, that because you are painting fog, you will have, at times, a strong, penetrating light which will give the picture an intensiveness totally unlike that of sunlight.

To paint the fuzzy background, keep the paper wet. Keep working down, leaving unpainted only really white areas, such as the boys' trunks and the top of the boat. Work from light to dark and keep the paper wet around the boat while at the same time establishing your values on the boat. The reflections of the boat should not be added until the paper is almost dry. In translating this tonal sketch into color, always remember that fog leans toward the cool side.

In painting a wet, rainy scene do not attempt to paint the soft edges. Instead paint it as you would any picture without sunshine. Then when the picture is dry, take your sponge and float some water on the painting. When this is semi-dry, take your 1-inch Grumbacher aquarelle brush, using the chisel edge, and delete the effects of the rain action with diagonal strokes. This will counteract the vertical lines of poles and trees as indicated in the picture. Reflections, such as in the street, are applied after the paper is dry.

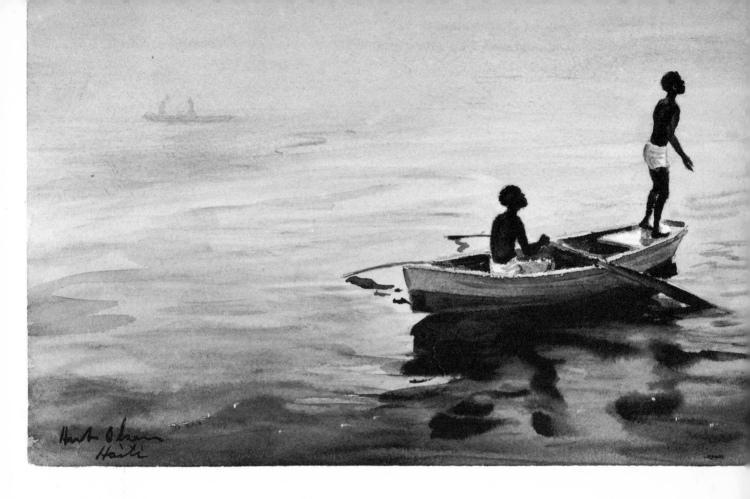

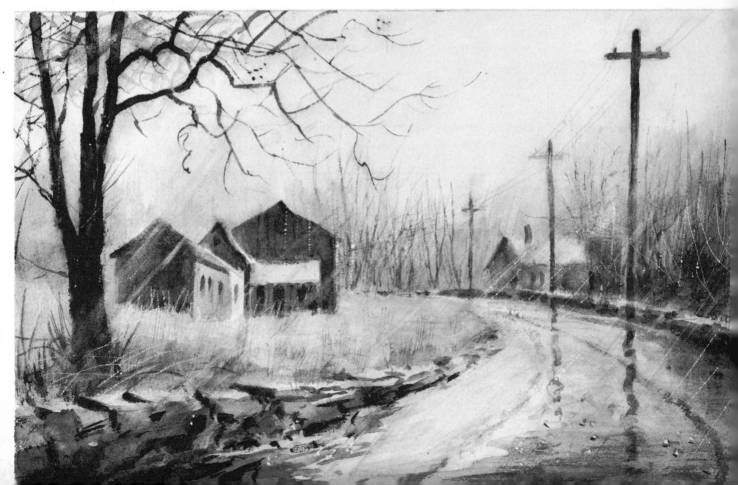

LIGHT AND HAZE

Remember in painting sunshine that there is but one source of light, the sun, and that the light comes from only one direction. If your painting is done all in one day, you may find that you started with the sunlight coming from one direction and ended with the sunlight coming from the opposite direction, thus changing the shadows. In doing your pencil drawing, always keep in mind not only the direction of the sun's light at the time you start, but also what time of day will make your shadows most effective and dramatic. When you have fixed the time of day when the shadows are most interesting, come back the next day at the same time to finish the painting. Also remember that shadows follow the basic laws of perspective in direction, length, etc.

On the opposite page, I have used a typical Bermuda scene, showing the softness and hardness of shadows in bright sunshine. In the bottom picture I have used a scene which depicts a harshly bright, sunless day in which the brightness has such intensity that the glare actually hurts the eyes. Light, under these conditions, will produce no shadows because the sun, although actually producing the light, is hidden by haze. In this particular case, it gives the picture an almost Oriental mood.

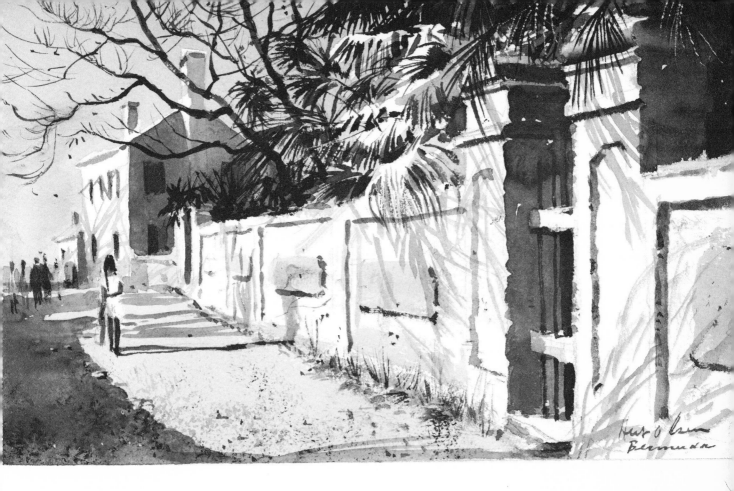

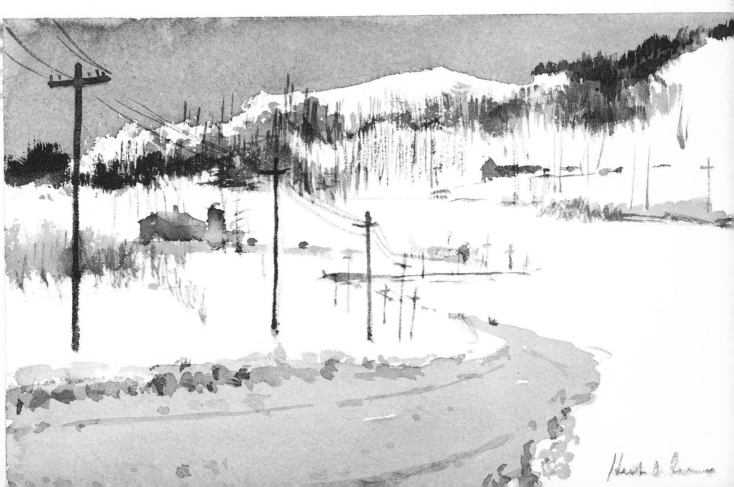

RESUME OF COLOR

If you have experimented with color as I suggest on page 47 and have tried translating a few black-and-white drawings into color, you will realize that values are the important thing. The best way to see values is to half-close your eyes.

If your values are right, there will be few people who can tell whether your color is right or not.

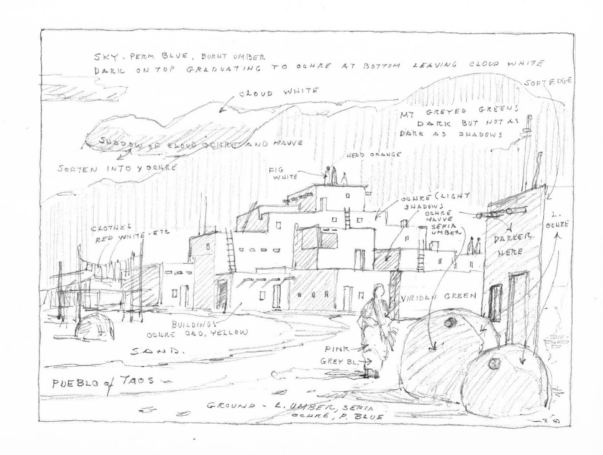

SKY - PERM BLUE, BURNT UMBER DARK ON TOP GRADUATING TO OCHRE AT BOTTOM LEAVING CLOUD WHITE

SOFT EDGE

CLOUD WHITE

MT GREYED GREENS DARK BUT NOT AS DARK AS SHADOWS

SHADOW OF CLOUD OCHRE AND MAUVE

HEAD ORANGE

SOFTEN INTO Y OCHRE

FIG WHITE

OCHRE (LIGHT SHADOWS OCHRE MAUVE SEPIA UMBER

L. OCHRE

CLOTHES RED WHITE - ETC

DARKER HERE

VIRIDAN GREEN

BUILDINGS OCHRE CAD, YELLOW

SAND.

PINK GREY BL.

PUEBLO of TAOS

GROUND - L. UMBER, SEPIA OCHRE, P. BLUE

FOUR SEASONS

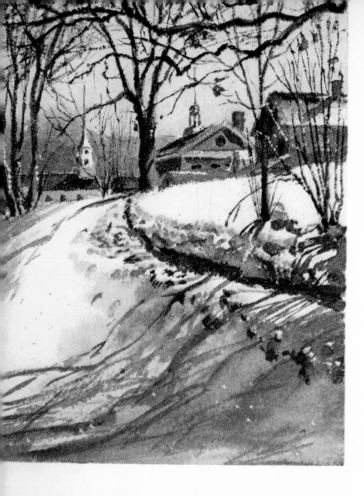
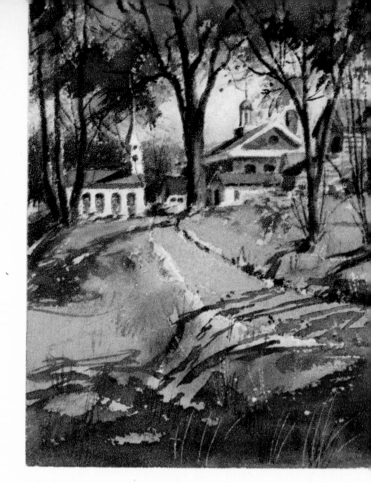
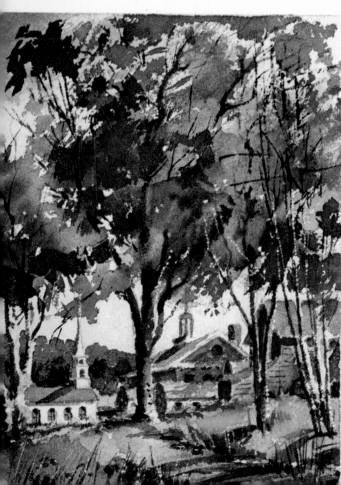
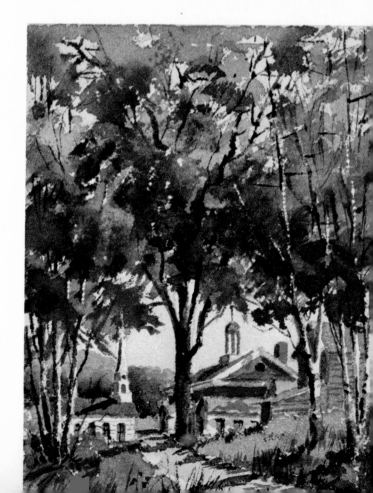

FOUR SEASONS

The same subject at the four seasons of the year is illustrated on the opposite page. In making the four rough color sketches, it was not my intention to ultimately finish four distinct paintings. It was to try to find out which season was most suitable to the particular subject matter.

In this experiment I found the winter and fall to be the most effective. In the spring and summer paintings, the monotony of green made these compositions less satisfactory. The winter scene, with a blanket of snow and cast shadows, lends itself to the placement of a high horizon line in the painting, giving more foreground. In the autumn scene, I have used a low horizon line because the elements of pictorial interest are above it. It gives the artist room to show the formation and character of trees, which makes the picture more interesting in composition and color. In the autumn one's instinct is always to look upward toward the trees and the sky for their vibrant symphony of breathtaking color. Note that when the horizon line is low the buildings appear larger; they are, however, identical as the four sketches were traced from the same drawing.

MASKOID

Maskoid is a liquid masking solution, applied with the brush, which forms a waterproof film when it dries and hardens. It can be peeled off without damage to the paper or surrounding painted areas.

As shown in the illustrations on page 59, Maskoid is applied to all areas that are to be left white. Note that, unlike rubber cement, it remains a visible color (gray) rather than transparent. This is very helpful in plainly indicating the areas that are to remain white. Another advantage over rubber cement is that small, intricate areas can be "painted," whereas cement is hard to manage on intricate detail. Wash your brush in soap and water immediately after using Maskoid, and do not use a good brush in applying it. Use a rubber cement pick-up to remove the Maskoid from your picture. Incidentally, note that I have signed my name in Maskoid on the picture, showing a further use for this versatile product.

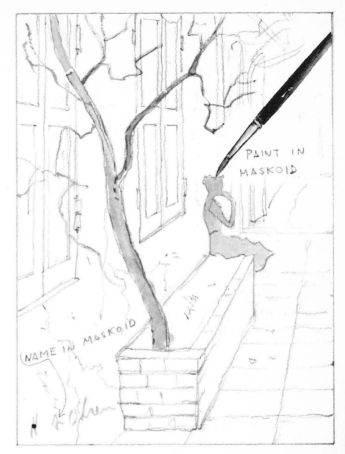

MASICOID

PAINT IN MASKOID

NAME IN MASKOID

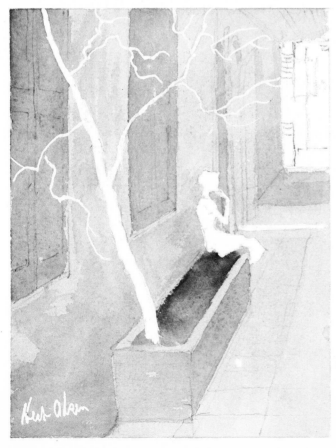

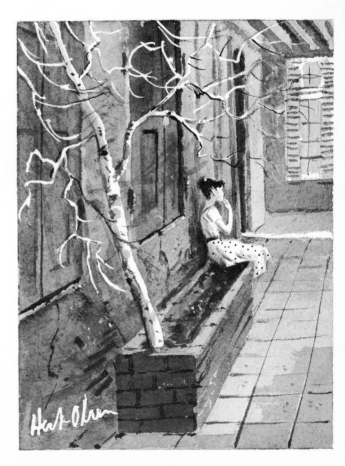

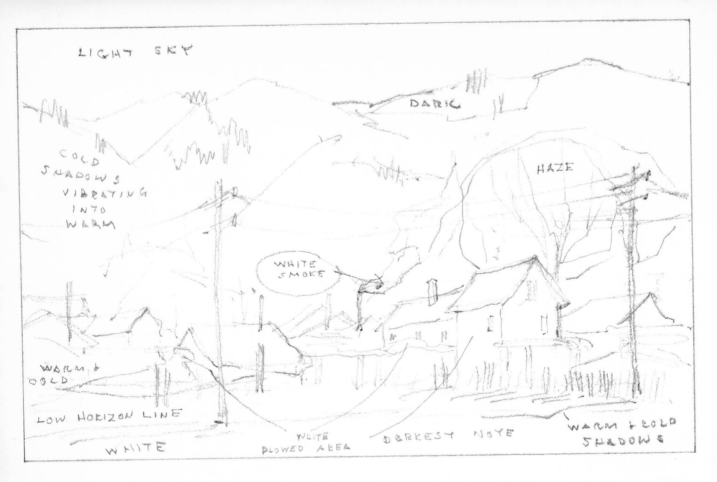

LIGHT SKY

DARK

HAZE

COLD
SHADOWS
VIBRATING
INTO
WARM

WHITE
SMOKE

WARM +
COLD

LOW HORIZON LINE

WHITE

WHITE
PLOWED AREA

DARKEST NOTE

WARM + COLD
SHADOWS

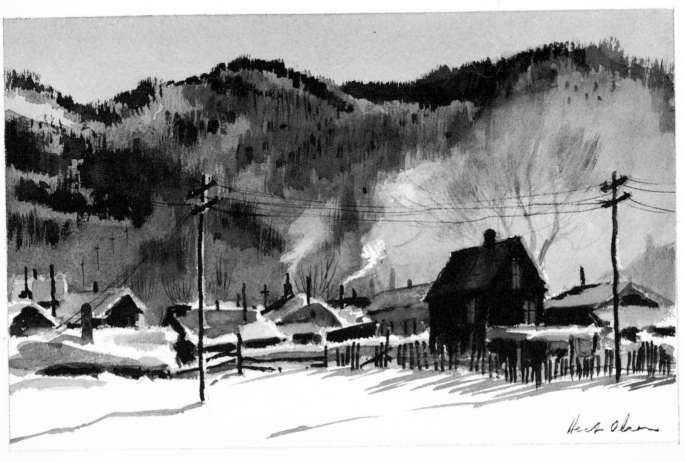

Herb Olsen

SMOKE

Smoke and smoke effects in watercolor are actually deleted rather than painted. The area surrounding the smoke plays a more important role than the smoke itself. This area should be painted in a cool note—lean toward blue and the cooler colors to accentuate the smokiness of the sponged area.

In starting the picture on the opposite page, I painted the entire background mountain to assure myself of the proper values in their entirety. Then, after painting the rest of the picture, I took a sponge and gently rubbed out the entire area affected by the smoke. The same treatment applies to the stack on the left.

When the paper had thoroughly dried after this sponging process, I then used sandpaper and brought out the pure white for contrast and effect. The completed painting "Colorado Winter" is shown in color on page 82.

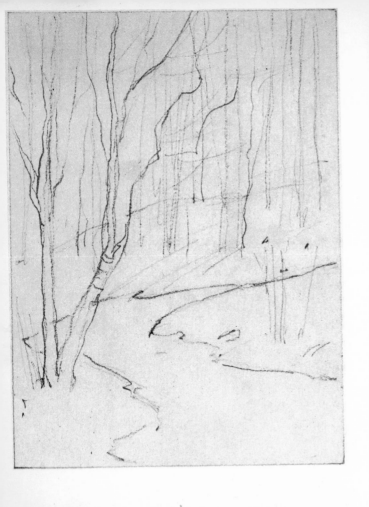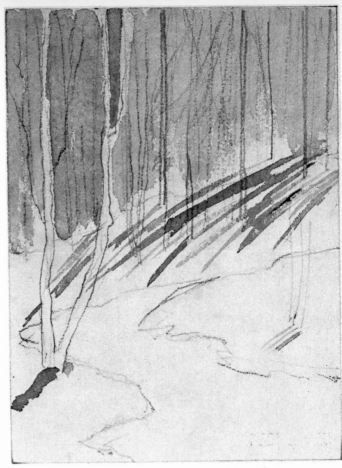

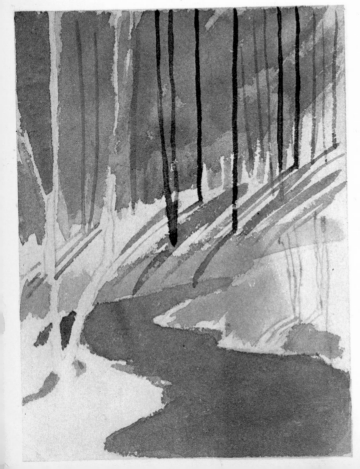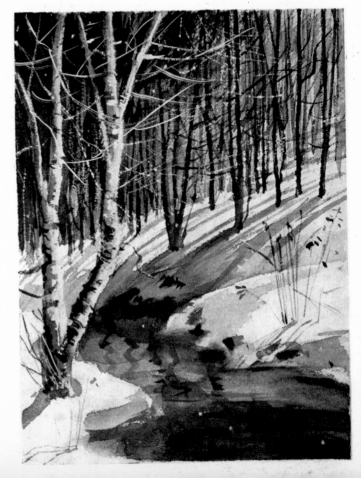

THICK OR DENSE WOODS

Opposite is a step-by-step demonstration of how to paint thickly wooded areas. After the pencil drawing is completed, paint in the light general tone of the entire area facing you (in this case it happens to be dense areas of browns) before attempting any of the trunks or structures. The white birch in the foreground will have Maskoid over it to protect the whites while other color washes are being applied.

The next step is to indicate shadows from the trees with blues and Indian red blended together, sometimes accentuating the blue, sometimes the red, but never making it ob-

vious. Note how the New England scene is painted on page 75.

The tree itself starting from the base of the shadow in the snow, is done with any dark earth color (see page 14). Next, the general tone of the river could be done with greens, umbers, and blues.

In the final picture, note that the birch is the last thing to be painted. Remove the Maskoid before painting. Now fill in the background—the limbs, twigs, dead leaves, and other details which, of necessity, have to be held until the last. This also includes the reflections on the water.

THE EFFECT OF LIGHT ON FORM

Just as there is no color without light, so there is no form. No surface vegetation grows without light, and the direction of the light determines the direction in which vegetation will grow. Opposite I have diagrammed the sun's journey from east to west, from sunrise to sunset. As the sun casts its changing rays on the little acorn through the years, it gradually grows into a majestic oak, perfectly proportioned and in full bloom. However, if the sun were to remain stationary, branches and foliage would grow only on that side of the tree exposed to the sun's rays. To make the tree appear natural, draw it with shaggy lines, as few trees grow with absolutely smooth edges. Start drawing from the ground up, as the tree grows, and twist pencil from side to side as you draw the line. To give the trunk and branches roundness, keep edges soft. Another phenomenon of the tree growth not generally known is indicated by the dotted line in the illustration; that is, the roots will grow to the same width as the width of the widest spreading branches.

In the middle illustration, one tree limb is shown with foliage on the top and none on the bottom, which is further evidence of the effect of the light's direction on growth. In the lower illustrations, part of the root formation is shown. Treat this area pretty much as you would treat growing branches, gradually losing the roots in the earth. Don't stick the tree in the ground as if it were a telegraph pole. Paint it the way it grows, rhythmically and proportionally.

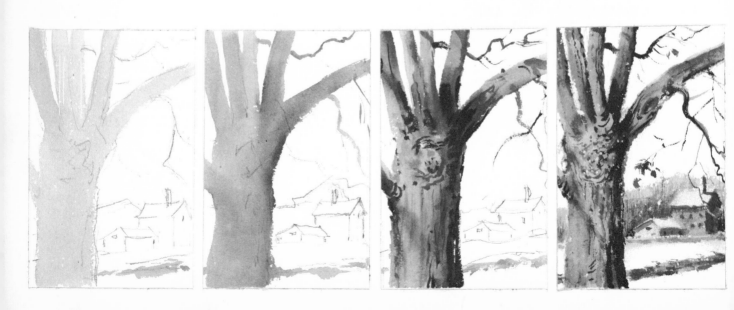

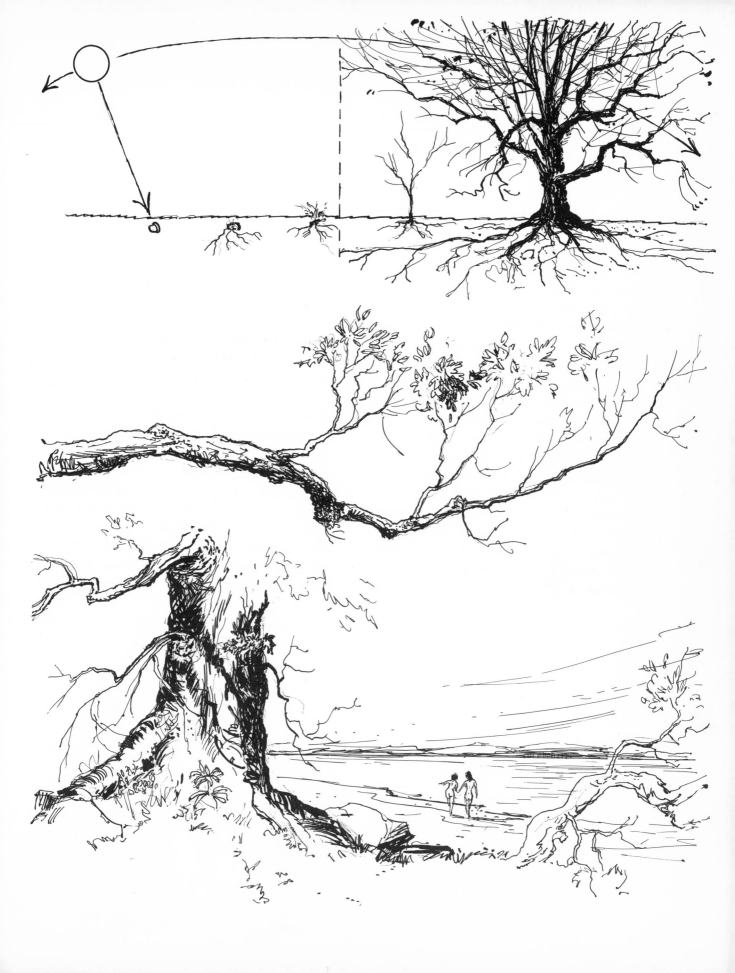

CONNECTICUT FARM

To paint tree trunks and branches, first complete the composition and planning of the picture. Carefully draw the tree by pushing your pencil upward, rolling it between your fingers as you push in order to get the bark-like irregularity of the tree's outline. Then use a very thin wash of ivory black and use it quite wet (see bottom of page 64).

While paper is still wet, add orange in the warm areas of the tree but do not cover black paint completely. Note how colorful black can become.

Now use darker color notes where shadows are necessary, thus giving the tree dimension and character. These shadows are soft because the painting is still moist.

After paint is dry, complete tree textures such as bark, nodules around knots, etc.; then paint in the background in a diffused manner. This will make the tree the prominent part of the picture. Try the same method on other trees, using other colors, such as green (mossy effect), blue, and sepia. The results will be fascinating as well as instructive.

To paint summer leaves and foliage, first put a wash of lemon yellow over the area where the sky does not show.

While this is still wet, lay on a wash of orange and Hooker's green for first value, showing the light coming from the left.

Now put on your third value of sepia, orange, and Hooker's green while painting is still wet.

When all color is dry, add the trunk and twigs in the slots where the sky appears and also add a few leaves on the outer edges.

In painting a tree, always try to identify it by its general structure and indicate the time of year by its foliage or lack of it. The color picture on pages 68–69 shows the results that may be obtained by incorporating some of these suggestions into a painting.

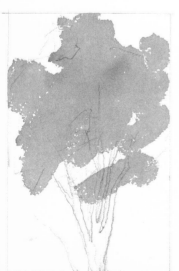
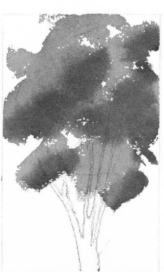
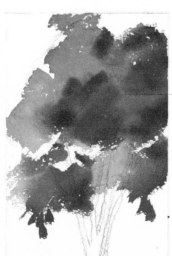
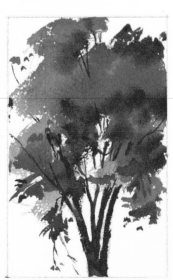

CONNECTICUT FARM

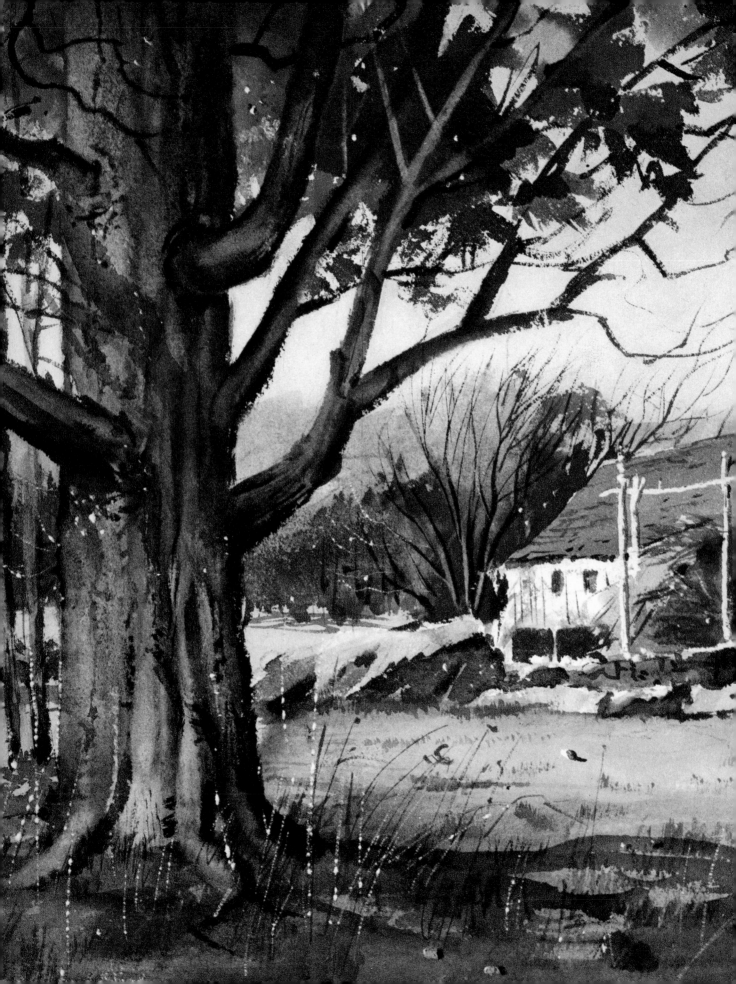

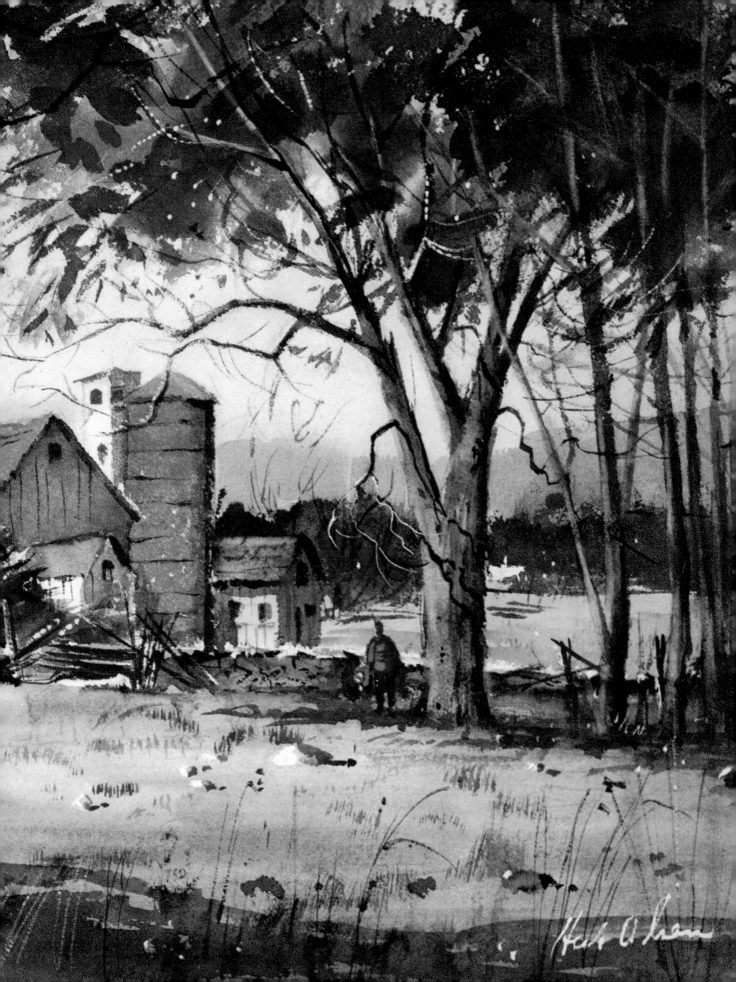

LIGHT TO DARK

Paint in sky with a light tint of ochre and while it is still wet brush very lightly with a stroke or two of Payne's gray.

Using the illustration at the bottom of page 82 as a color guide, paint the blues in the shadow area behind the trees and on the hillock, foreground.

Paint in the trees on the mountainside and darken the shadow area on the hillock.

Put in tree in any dark color, preferably sepia, Antwerp blue, and Indian red blended together in such a way that no one color is obvious.

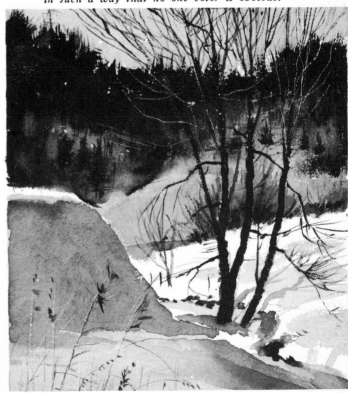

WORKING FROM A PENCIL SKETCH

There are times when one is struck by a breath-taking scene that may never be encountered again. The color picture I did which is shown on page 75 resulted from just such an experience. Should you lack a camera in a similar situation, put your pencil to use and do a quick sketch of the scene with detailed pencil notes about the actual color. This will give you a chance to apply your knowledge about the warm and cool classifications of color because it will be almost impossible to remember each individual color by name. A sketch like this, as you can see, is not too detailed, yet it includes the essential elements in proper relation to each other. It will probably be helpful to analyze the drawing without the notes. See how abstract the little tree at left and the larger one at right are. Notice that the hills in the background are merely outlined and the woods at left and right, as they get nearer, are still merely wiggly lines. Buildings, too, are merely indicated rather than actually constructed.

When you get back to your base of operation, make an immediate color sketch based on the drawing and notes made on location as well as anything you may be able to remember and visualize about the scene. This procedure will give you a solid basis for a future finished painting.

Note in the lower drawing how I have saved the center building and large tree for the last. These are my darkest darks.

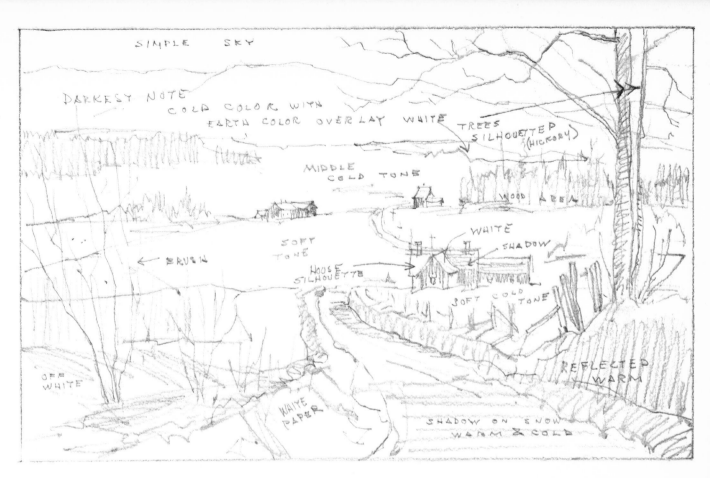

SIMPLE SKY

DARKEST NOTE
COLD COLOR WITH
EARTH COLOR OVERLAY WHITE

TREES
SILHOUETTED
(HICKORY)

MIDDLE
COLD TONE

WOOD AREA

SOFT
TONE

WHITE
SHADOW

BRUSH

HOUSE
SILHOUETTE

SOFT COLD TONE

OFF
WHITE

REFLECTED
WARM

WHITE
PAPER

SHADOW ON SNOW
WARM & COLD

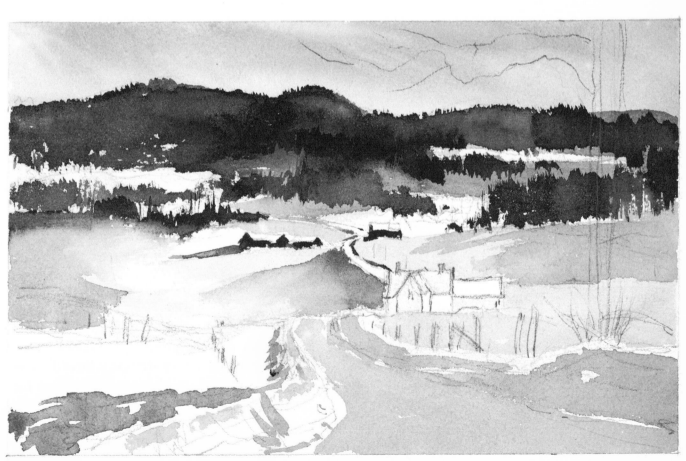

WINTER MOOD

Here is the final painting in full color of the stages explained in the previous pages. In the sky, I first used a thin wash of ochre with a touch of Antwerp blue, emphasizing the ochre. I then washed over that with ultramarine blue, introducing just a touch of burnt umber applied very lightly. In this particular instance, I did not sponge the sky area; it was painted with a wash.

While the sky was still damp, I painted the hills with areas of blues—permanent Antwerp, and cobalt—spotting them in different areas but graying them all with umber and Indian red. When this was finished, the darker areas of the mountain and background were painted, leaving only the areas that are to remain white unpainted. I used sepia, Antwerp blue, and burnt umber, graying their intensities. The trees and all details in the background were painted this way, using the colors of winter.

Next, the foreground of the road was painted and, when that was dry, the shadows were put in as indicated in the painting, this time using cadmium orange with the same blues. I finished by painting the house and foreground tree and other final touches.

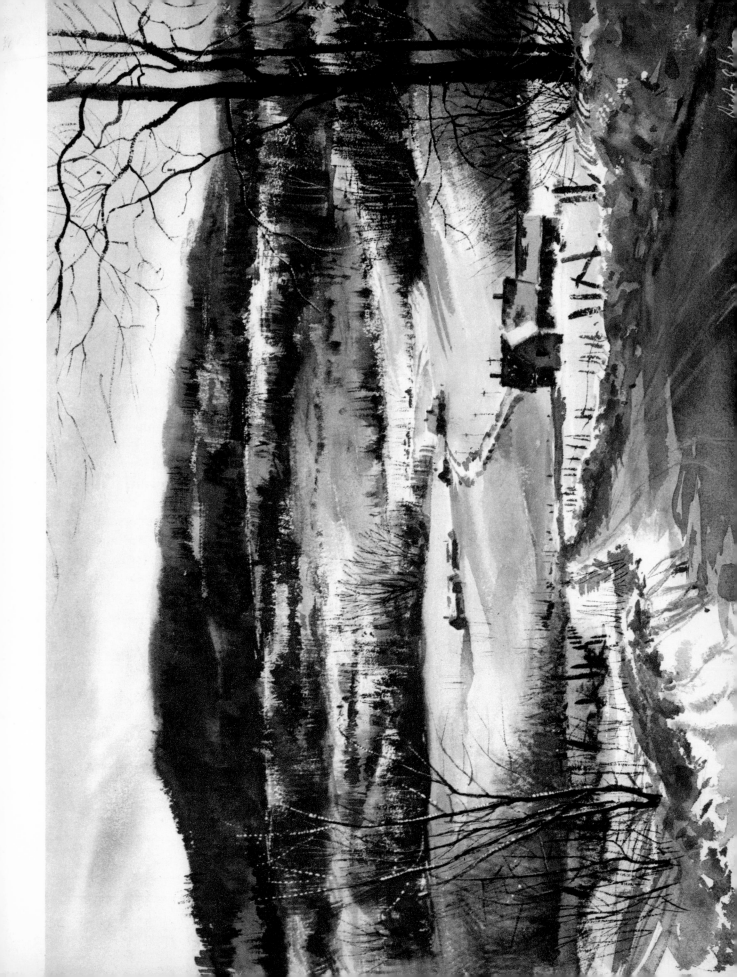

WINTER MOOD

MOUNTAINS

A mountain usually consists of a series of irregular triangles. The pencil sketches at the bottom of this page are an illustration of this point. What gives the mountains form is the direction of the light; this light, plus the shadows created by the light, gives them their appearance of bulk and solidity.

At the bottom of the page, I have taken the pencil sketch and by the introduction of light and shade have given it a feeling of depth and dimension. By the use of small objects in the foreground, such as the boat, the tremendous size of the mountains is accentuated.

On the following page are four stages in painting a mountain.

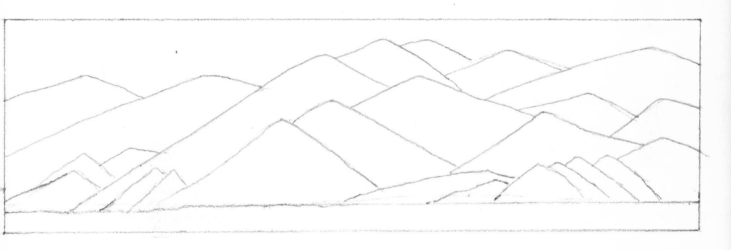

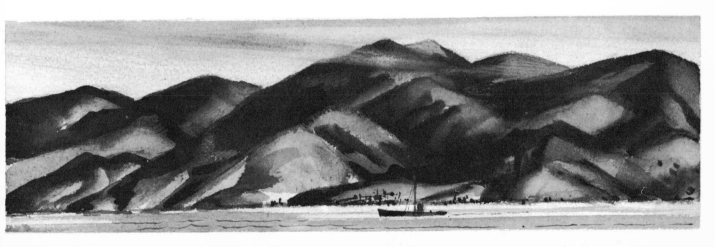

step 1. *Paint the mountain farthest away in the lightest tone and carry it down to the base of the nearest mountain.*

step 2. *In the middle range, starting at the second range of mountains, take your second value and carry that down in a similar manner, leaving the first mountain in its original tone.*

step 3. *Paint mountain closest to you in your third value.*

step 4. *Then, in completing the picture, paint in the darkest tones.*

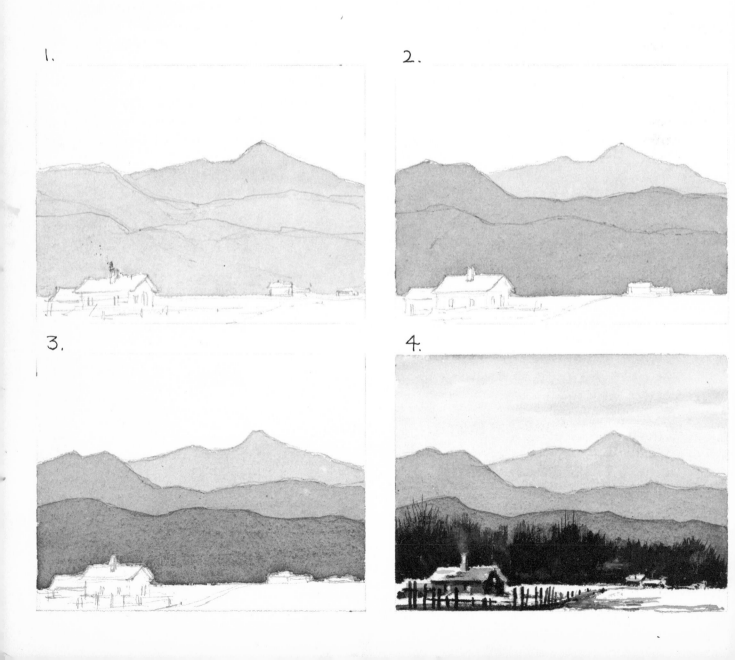

1.

2.

3.

4.

WINDOWS

One of the most frequent queries I've had during my years of teaching is "How do you paint a window?" It is essential to learn this if you are to paint buildings successfully. A window, of course, is transparent, but often it also is a reflecting agent.

At the bottom of the page are three stages in painting a window. First, apply a wash of Payne's gray and yellow ochre. While this is still wet, apply a darker wash of the same with a touch of Antwerp blue at the top of the window (stage 2). When this dries, paint the frames. Should you wish to put in a curtain as indicated, paint a dark area to the center and then add other, less dark, values for wrinkles (stage 3).

On the following page are shown two types of windows—one, such as that illustrated below, and the other, a shack window. The same procedure is used in these, only note in the fishing shack that I have left one pane lighter than the others to lend an interesting contrast. The pencil sketch shows how this window was constructed.

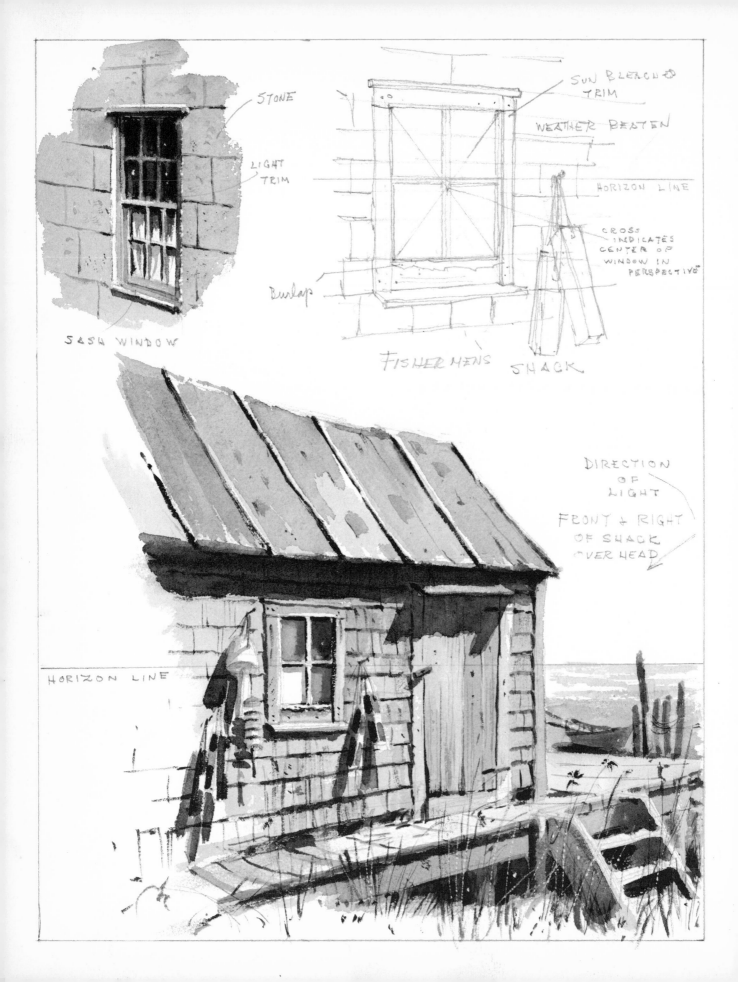

STONE

LIGHT
TRIM

SASH WINDOW

SUN BLEACHED
TRIM

WEATHER BEATEN

HORIZON LINE

CROSS
INDICATES
CENTER OF
WINDOW IN
PERSPECTIVE

Burlap

FISHERMENS SHACK

DIRECTION
OF
LIGHT

FRONT & RIGHT
OF SHACK
OVER HEAD

HORIZON LINE

YOUNG TRADERS-HAITI

COLORADO WINTER

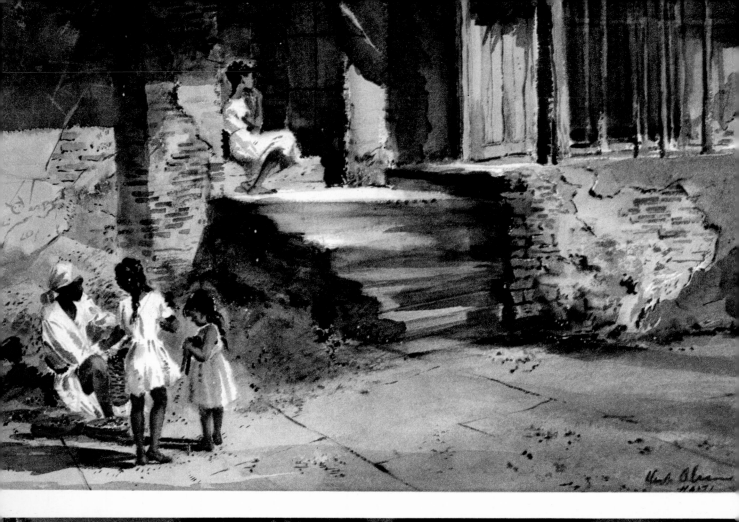

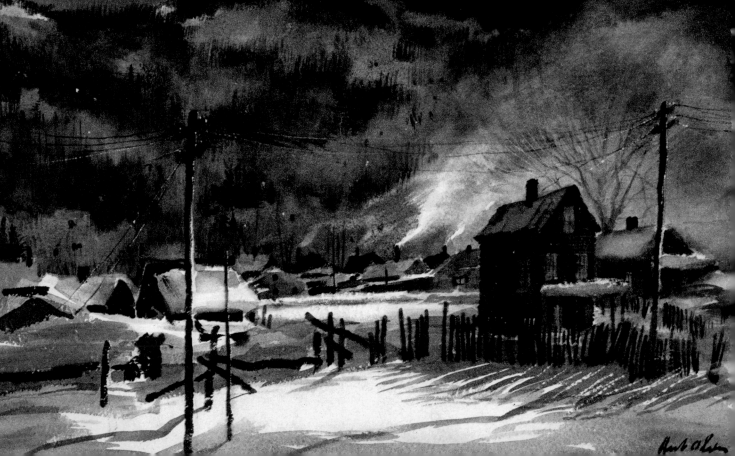

YOUNG TRADERS-HAITI

The picture at the top of the opposite page, "Young Traders—Haiti," appealed to me because of the texture of the building walls. As you will note, there is cement over brick, and the old brick showing through the broken stucco made an interesting pattern. This picture was painted from pencil sketches and photographs made in Haiti and finished at my studio.

In painting this picture I worked in my usual way of light to dark. I kept the entire picture moving at all times, covering all surfaces that were not to remain white, and worked like a sculptor, modeling and giving form to things. The last areas to be painted were the textural effects of the bricks, the stones, and the sandy areas, which were dabbed with a sponge. The contrast of the soft texture of the dresses against the hard structure adds an interesting effect.

COLORADO WINTER

At the bottom of the opposite page is a scene called "Colorado Winter." The text on page 61 on smoke applies to the execution of this picture.

TEXTURE

On the opposite page are two very commonplace subjects in Connecticut—an old barn and a stone wall. The silvery quality and rotten, weather-beaten wood, complete with knot holes and rusty hinges, make the barn an intriguing subject for professional and amateur artist alike. This also applies to the picturesque New England stone wall. Both subjects are a challenge to any artist because of the subtleties of textures involved.

Notice how the structure of the fence wall is placed within a cube in order to get the proper dimension and perspective. Having done this first, then break up the wall into an interesting, irregular pattern.

To achieve the texture of the old wood in the barn, work from light to dark—a series of light washes. For the silvery quality of old weather-beaten wood use a thin wash of black. To show wood that is warped, work from the basic middle tones up through lighter tones to the dark shadow edge. Many of the texture effects are achieved by using an almost dry brush. Remember, it takes time and patience to get good texture. Don't finish any specific area—work over the whole picture until it is completed. If your light area gets too dark, use a bristle brush with clean water to make it light. If the area is large, use a sponge.

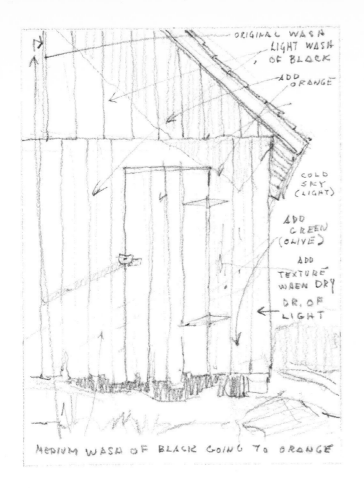

ORIGINAL WASH
LIGHT WASH
OF BLACK

ADD ORANGE

COLD
SKY
(LIGHT)

ADD
GREEN
(OLIVE)

ADD
TEXTURE
WHEN DRY

DR. OF
LIGHT

MEDIUM WASH OF BLACK GOING TO ORANGE

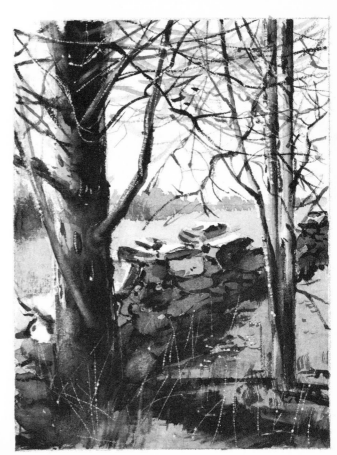

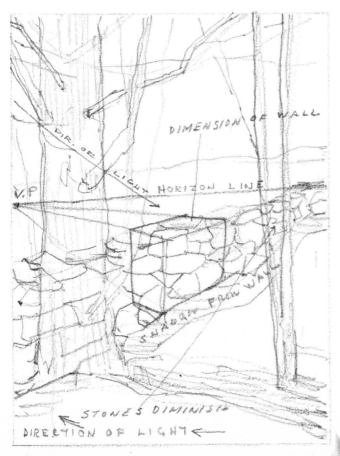

DIMENSION OF WALL

DIR. OF LIGHT

V.P

HORIZON LINE

SHADOW FROM WALL

STONES DIMINISH

DIRECTION OF LIGHT

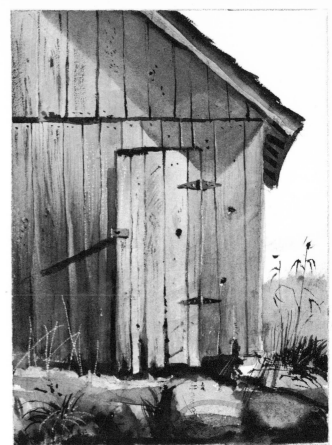

EDGES

When you get the feeling that an object has that "pasted in" look, you can be sure that there is something wrong with your edges. Notice in the top painting on the facing page, "Acoma, New Mexico," the outlined or hard edge throughout the picture. I call this a railroad track. Nothing is left to the imagination and all textures suffer. When looking at nature, half-close your eyes and see how few really hard edges there are.

In the painting below, observe that nothing is outlined. In the girl's dress, part of the white skirt runs into the picture. An outline is unnecessary; here form expresses itself, and your eye completes the picture.

Notice the rough edge on the house in the left corner foreground. This erose edge is an example of how rough paper aids the artist as the brush skids over the paper. If this line were sharp, it would resemble metal rather than old adobe over brick.

You can also soften an edge. You do this with water, blending the colors so that the distinct line is lost.

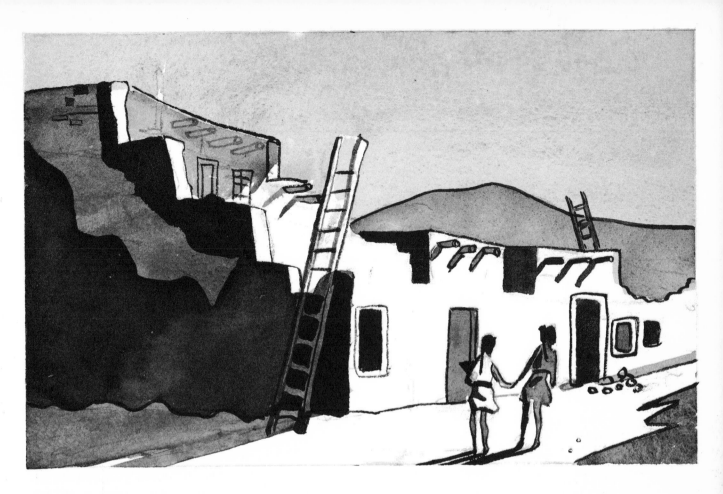

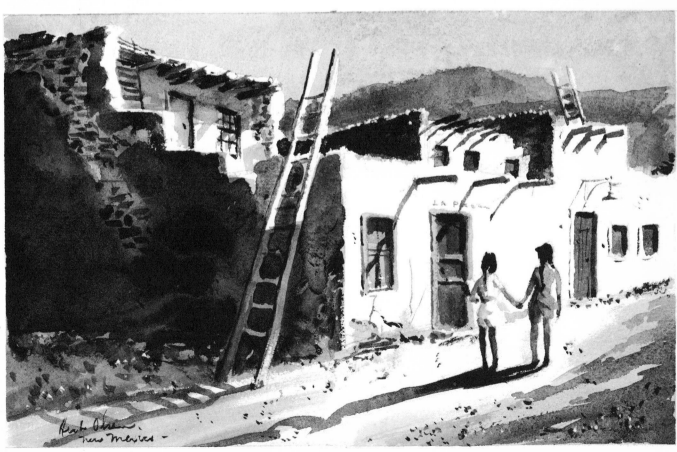

INTERIORS

In choosing an interior to paint, pick something that is of special interest. "Allen's Clam House," on the facing page, is an example of an unusual subject.

In the top picture of the three thumbnail sketches shown at right, I planned to show a complete interior of this Westport clam house. On second thought, I felt that the picture would be more interesting if it showed a bit of both interior and exterior (center sketch). This decision proved to be wrong because it divided the picture in half, making two pictures and thus dividing the interest. In the bottom sketch I made an abstraction, using most of the interior, and I finally settled on that composition for the finished drawing. This is, by the way, another example of the help given by the use of abstraction in effective composition (see page 28).

On the opposite page is my pencil drawing of the final thumbnail composition with color notations. Below it is the finished picture, in which I have deliberately fogged the exterior in order to focus interest on the interior.

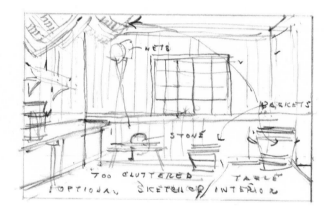

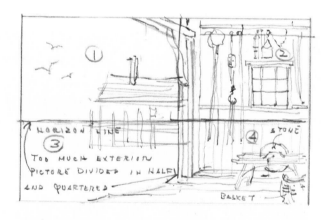

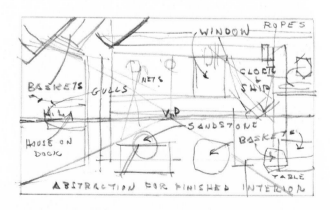

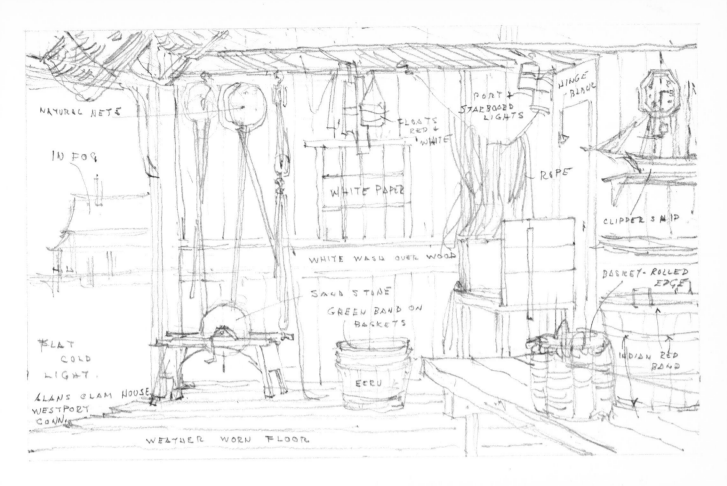

NATURAL NETS

IN FOG

H.L.

FLAT
COLD
LIGHT.

ALANS CLAM HOUSE
WESTPORT
CONN.

WHITE PAPER

FLOATS
RED &
WHITE

PORT &
STARBOARD
LIGHTS

HINGE
BLACK

ROPE

WHITE WASH OVER WOOD

SAND STONE
GREEN BAND ON
BASKETS

ECRU

WEATHER WORN FLOOR

CLIPPER SHIP

BASKET-ROLLED
EDGE

INDIAN RED
BAND

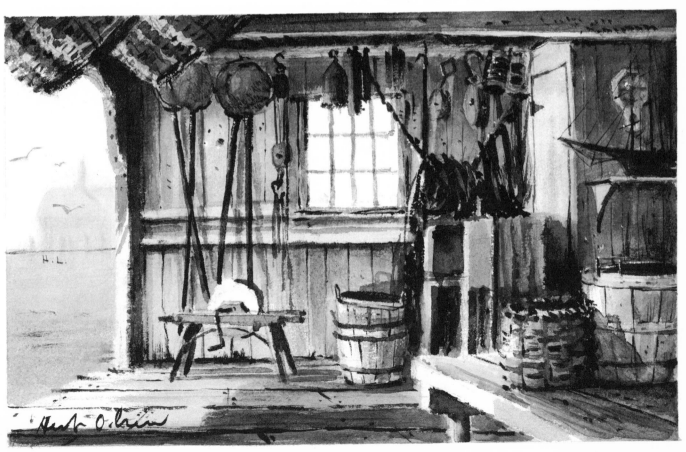

H.L.

ORCHARD STREET

The street scene shown on the opposite page and the one shown in the frontispiece are interesting vignettes of the seamier aspects of city life.

Before painting either of these pictures, I took a number of photographs, finally choosing, in "Third Avenue," the period of day when the lighting conditions were most interesting—around 4 p.m. I did not paint either of these pictures on the spot but used knowledge acquired on location for a more detailed and interesting studio rendition.

"Orchard Street" shows another aspect of city life on a rather dismal day. "Third Avenue" is nearly completely representational, but "Orchard Street" is a composite of impressions of an area. "Third Avenue" has a softening trace of sunshine, and "Orchard Street" is shown right after a rain storm. Both pictures convey a mood of bustling city activity.

The street scene, like the figure, is not for the amateur painter. As a matter of fact, I have been approached by experienced painters who have found the street scene a bit elusive. I include it here not only because it is a phase of American life but because of its great interest to those who know only that phase of life.

This picture was painted in the same manner as all my pictures are painted—from light to dark and finishing with detail. Both "Orchard Street" and "Third Avenue" were drawn with reasonable accuracy, but in "Third Avenue" the elevated structure was lost as the washes were applied. Possibly seven overtones were used to achieve the final effect.

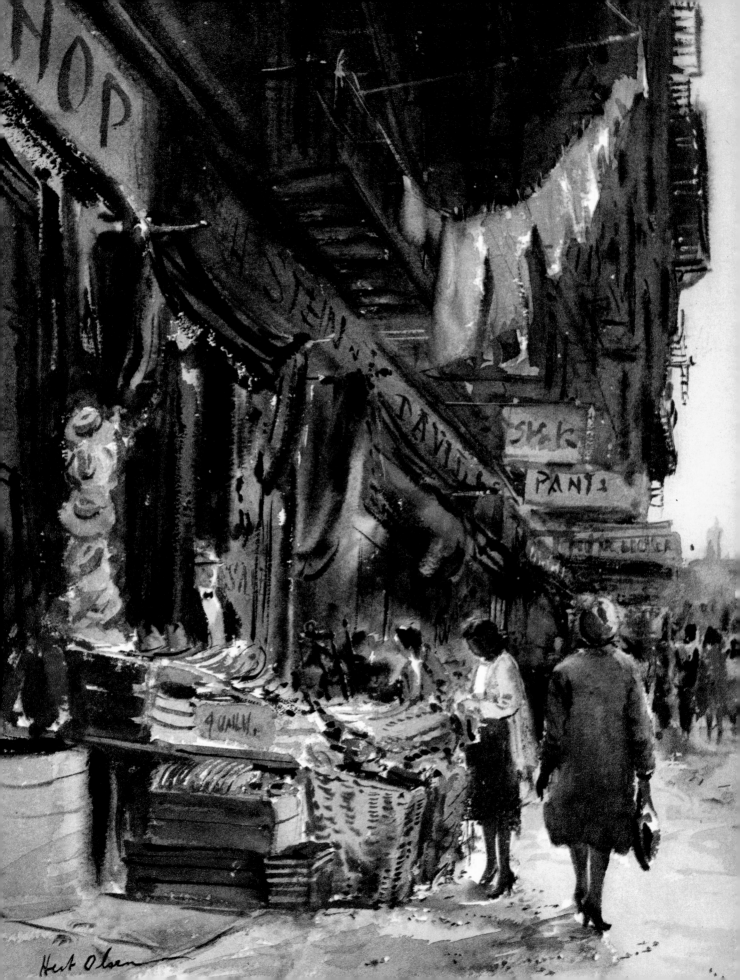

ORCHARD STREET

USE OF FORMS

I cannot stress enough the use of abstract shapes in composing a picture. In landscape painting there are large forms such as hills, roads, trees, buildings. Look for these forms before starting the composition. You can see the basic form more readily with eyes that are half-closed. After studying the subject, arrange the large shapes where they are most helpful to your composition. After this is done, break these into component parts.

Note below how a triangle becomes a fir tree and other shapes assume their respective characteristics. These demonstrations are helpful for indications in sketching.

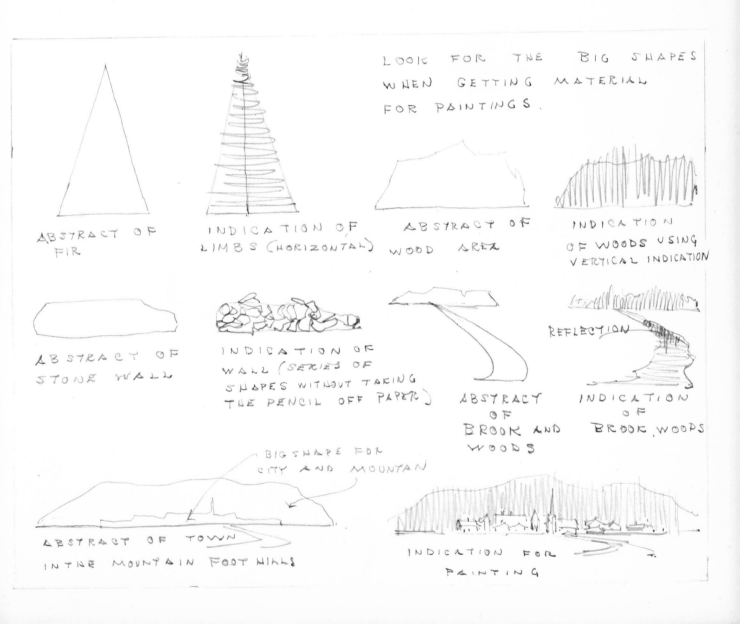

LOOK FOR THE BIG SHAPES WHEN GETTING MATERIAL FOR PAINTINGS.

ABSTRACT OF FIR

INDICATION OF LIMBS (HORIZONTAL)

ABSTRACT OF WOOD AREA

INDICATION OF WOODS USING VERTICAL INDICATION

ABSTRACT OF STONE WALL

INDICATION OF WALL (SERIES OF SHAPES WITHOUT TAKING THE PENCIL OFF PAPER)

ABSTRACT OF BROOK AND WOODS

REFLECTION

INDICATION OF BROOK WOODS

BIG SHAPE FOR CITY AND MOUNTAIN

ABSTRACT OF TOWN IN THE MOUNTAIN FOOT HILLS

INDICATION FOR PAINTING

BEACH SCENES

On the facing page are two contrasting beach scenes. One, with breaking surf, the other with the receding tide and calm. In the upper picture, I first painted the sky and background—the background, of course, meaning the sea itself where the water breaks against the rocks. Here, Maskoid would be very useful to cover the whitecap area of the waves and the mat knife can be used for the bits of spray (see page 97).

In the second picture, use a warm color for the sand, taking it right down to the first line of foam. Then where the wet area of the sand first appears, put a colder wash over the first wash in the broken line indicated and carry that right down to the foam. Third, for the wetter sand, use an overlay of the same color deeper in value.

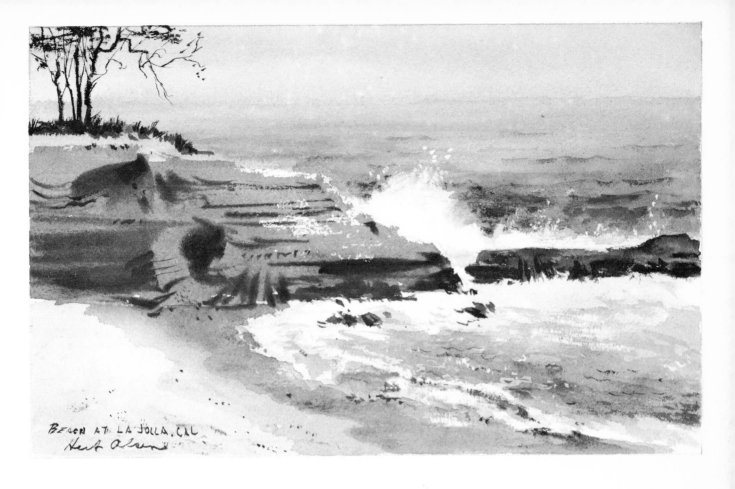

BEACH AT LA JOLLA, CAL
Herb Olsen

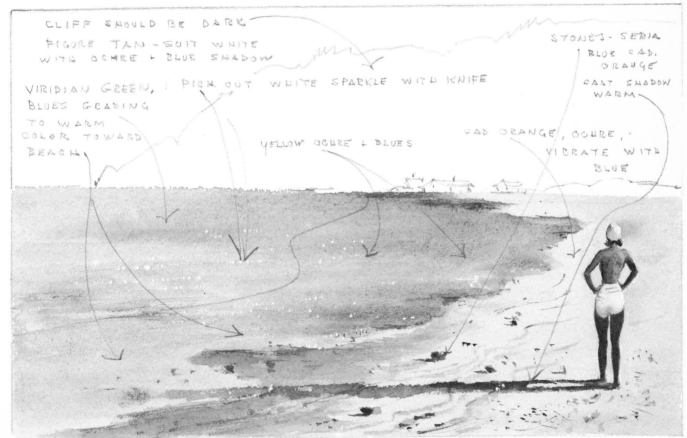

CLIFF SHOULD BE DARK
FIGURE TAN - SUIT WHITE
WITH OCHRE & BLUE SHADOW

STONES - SEPIA
BLUE CAD.
ORANGE
CAST SHADOW
WARM

VIRIDIAN GREEN, PICK OUT WHITE SPARKLE WITH KNIFE
BLUES GRADING
TO WARM
COLOR TOWARD
BEACH

YELLOW OCHRE & BLUES

CAD ORANGE, OCHRE,
VIBRATE WITH
BLUE

BEACHCOMBER

This picture was painted on the coast of California a few miles south of San Francisco. The curious jutting rock formations on the California coastline, coupled with the iridescence of the sand and water make this a picture of violent dramatic contrasts. The tiny size of the beachcomber against the massive structure of the rock and the sweeping motion of the sky and water gives one a sense of the vastness and majesty of nature. The unique part of this picture in execution is that practically all of the white areas that you see in the water were scraped out with a mat knife.

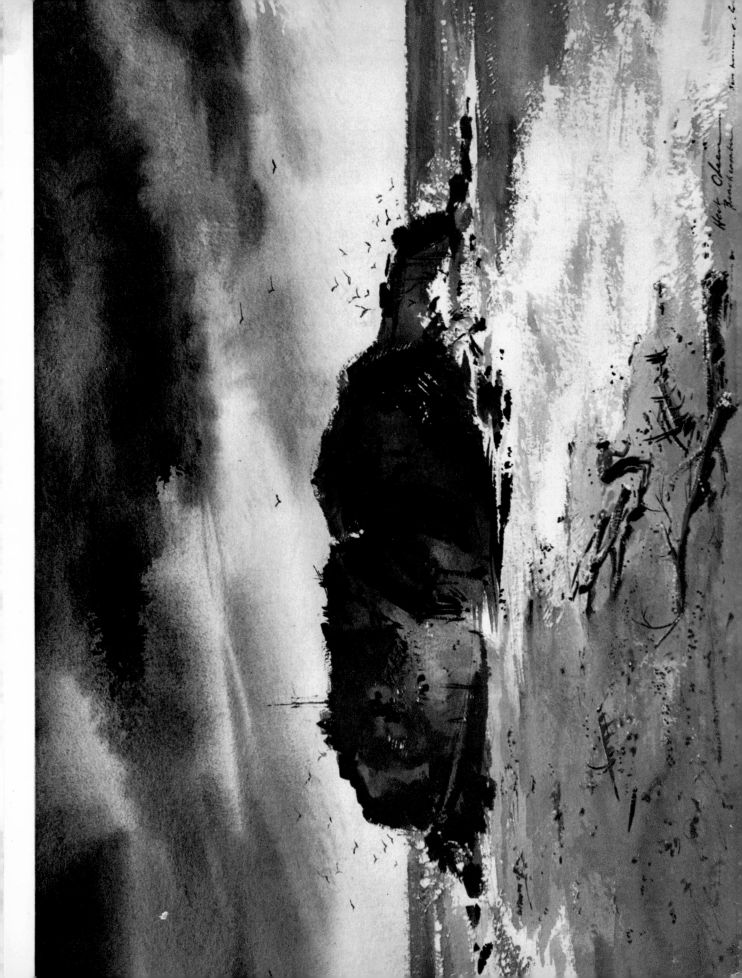

BEACHCOMBER

DEMONSTRATION STEP-BY-STEP

the snapshot

In choosing the scene you are to photograph, be sure not only that it serves your purpose but that it stimulates and excites you. You cannot do a commendable piece of work unless you are deeply interested in the subject matter. In this case, you can refer to the final watercolor on pages 104 and 105 to see the kind of inspiration I got from this particular snapshot.

The photo I have chosen for these demonstrations interested me because of its shapes. When I work from a photograph, I find it less constraining to use it as an embryo, using only the basic forms of the picture from which to construct my painting. I first made several pencil roughs to determine what to retain and what to invent. This photo was taken by me and was not intended to be a great example of photography. I would suggest that you use your own photos and not something that has appeared in a publication because it can be dangerous to originality. Somebody else has done all the thinking to produce that particular picture.

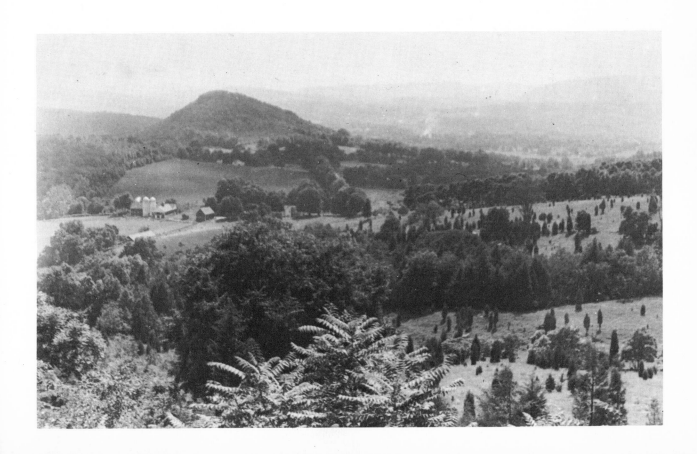

the thumbnail sketch

On the bottom of the page are four thumbnail sketches which were made from the snapshot on the preceding page. In making my thumbnails, I purposely chose the four seasons to show that you are not bound to the particular season in which the photograph was taken and also to show how much latitude there is for one's creativity.

Note that in all four of the sketches I have retained the background almost in its entirety. Only the foreground and middle distance has been changed. I chose to do the autumn scene. To me, a native Midwesterner, autumn is the most inspiring season in New England.

The following five pages contain the balance of this demonstration from the final drawing which, as can be seen, developed from one of the thumbnail sketches to the final painting spread on pages 104 and 105.

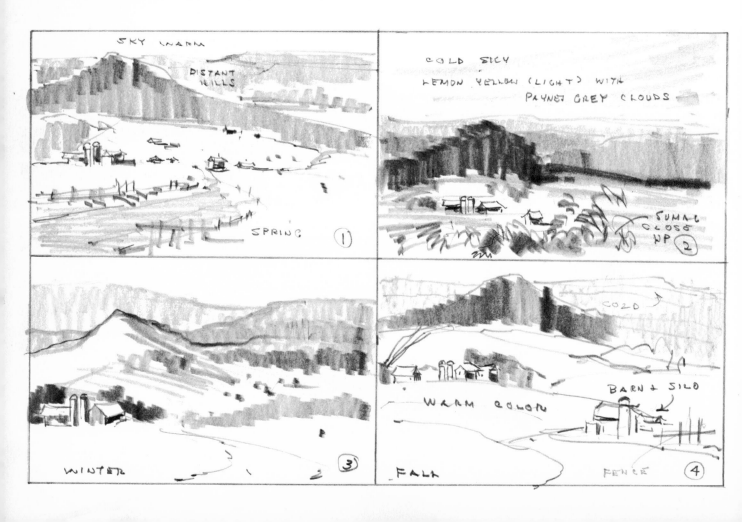

step 1. *Sponge sky area wet into the hills. Use a very light wash of ochre in the sky and, while the sky is still damp, use Payne's gray for cloud effects, using a three-inch soft brush. While all this is still wet, paint over entire hill area with ultramarine blue and burnt umber.*

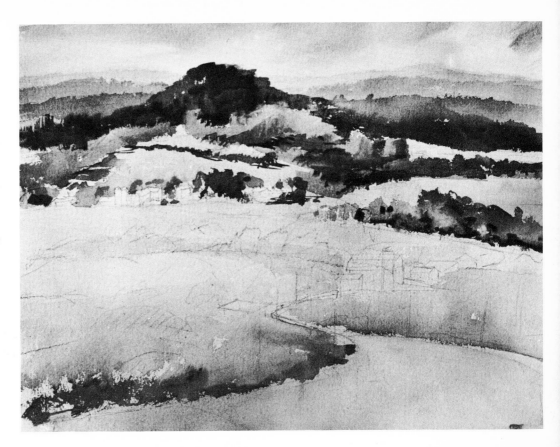

step 2. *Throw a wash of lemon yellow and ochre over the large hill; then for the general tone of fall blend over the entire picture a very light wash of the following colors: Indian red, cadmium red, Hooker's green, cadmium yellow, Rembrandt green or viridan. Mix these colors on the paper, not on the palette, but be sure they are mixed. Remember also to leave all white areas white.*

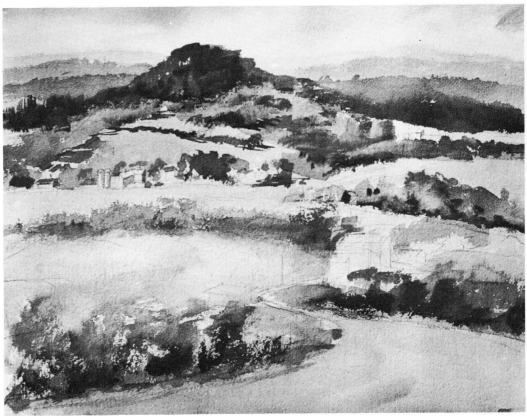

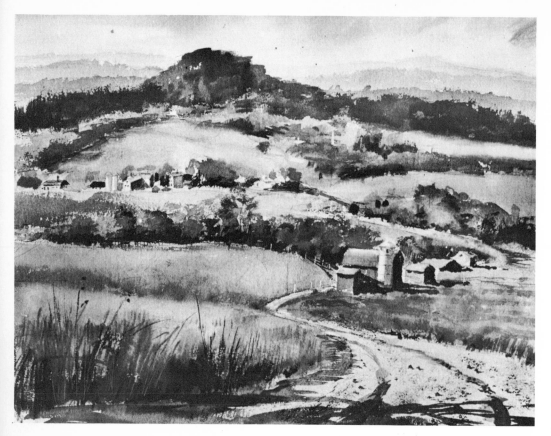

step 3. *When the paper is dry, apply second value of distant hill, leaving the first value as is. After this is dry, paint the third value of the hills and continue this deepening value sequence until all the hills are completed. While the hill area is drying, continue working in the foreground, spotting your trees and vegetation. In other words, keep your painting moving.*

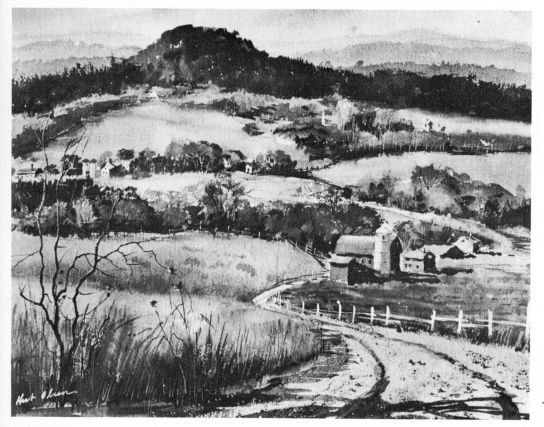

step 4. *You are now nearing the final stage of your completed picture. Paint the main hill (final color is shown in the completed painting on the spread 104 and 105). The dark areas throughout, especially the shadow areas at the base of the painting, help to pull the picture together.*

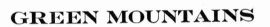

GREEN MOUNTAINS

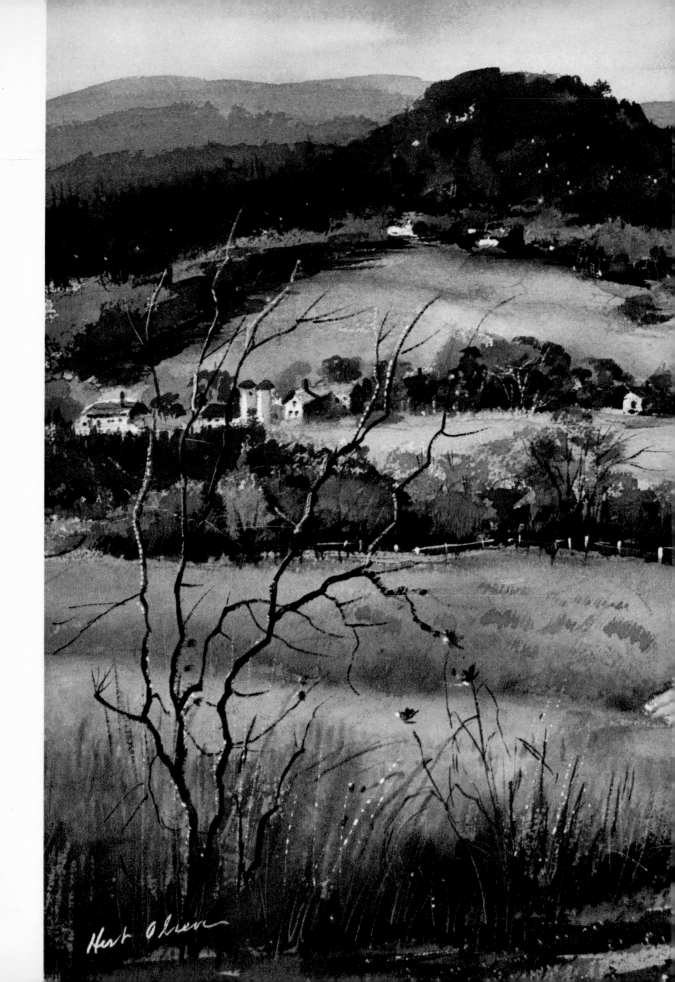

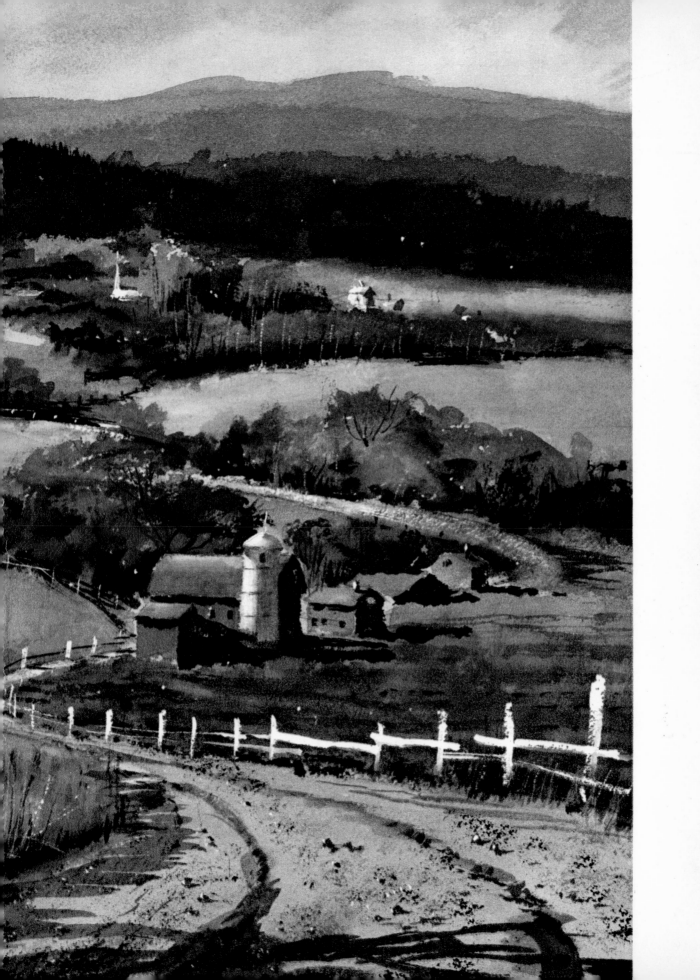

CONTRAST

In the painting on page 108 an Arctic scene is shown. In the Arctic regions, of course, the vegetation is sparse because there is little sunlight during nine months of the year. This utter bleakness has a stark, dramatic quality which gives the picture power; the rays in the background emphasize this point. The picture was painted in cold colors typical of the region. The only warm color used was in the sky. The effect of the rays was obtained by using a gritty eraser.

The Mexican scene on page 109 was painted almost entirely with a warm palette. Blues were used in the shadow area of the tarpaulin. All sunlit areas were left light. The scene was painted in Tomazunchale, Mexico.

In painting each of the two contrasting pictures, I made the pencil notations for color to aid me in completing the paintings later in the studio. These are rough thumbnail sketches showing how the paintings were planned.

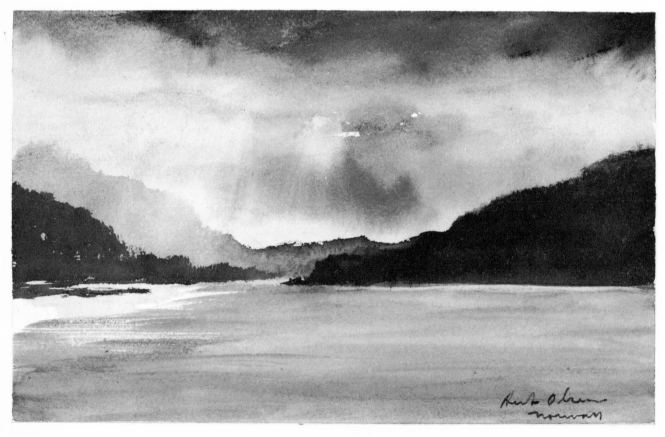

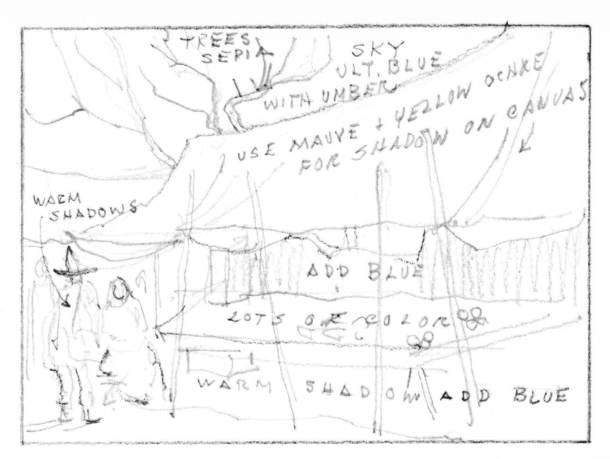

TREES
SEPIA

SKY
ULT. BLUE
WITH UMBER

USE MAUVE + YELLOW OCHRE
FOR SHADOW ON CANVAS

WARM
SHADOWS

ADD BLUE

LOTS OF COLOR

WARM SHADOW ADD BLUE

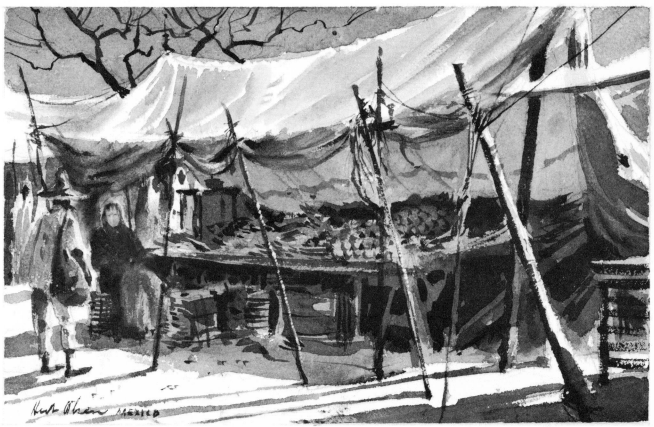

Hurt Olsen MEXICO

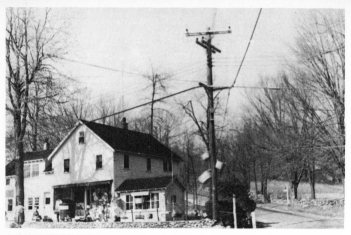
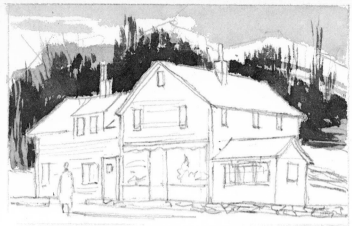
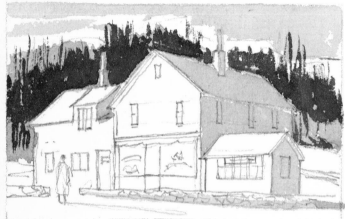
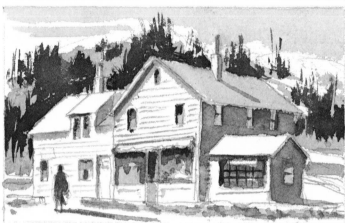
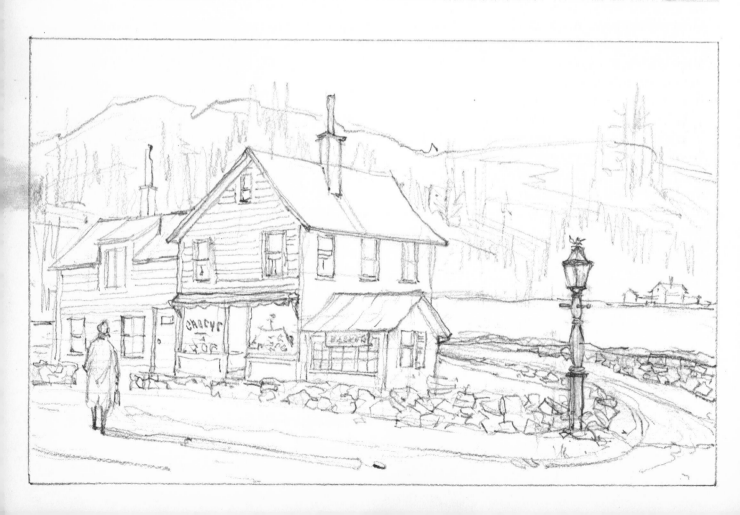

PAINTING A COUNTRY STORE

The reason I chose this particular country store was neither because of its setting nor its beauty, but because it took me back to another era. There seems to be an over-powering nostalgia about a country store with its incredibly varied merchandise (from horse shoes to the latest cosmetics), its mail delivery, its hot stove in winter. It is an atmosphere in which city folk become relaxed because tension is lacking. It is this atmosphere that you should seek to create in your picture, not merely the visible forms that confront you.

Whenever you are painting a picture of a bygone day, try to project yourself into the mood and pace of the era, whether it be the excitement of an election eve in the '90's or the acrid smell of a blacksmith shop. If the mood is captured, your picture will make people stop and look, which is exactly what the artist, no matter how modest, wants them to do.

The sequence on the facing page shows how to paint a country store. It will be noted that the drawing bears little resemblance to the snapshot. Since this particular telephone pole has little charm, with or without hand woven baskets, it was deleted along with the tree to the left. By removing the baskets in front and leaving things behind the win-dow vague, yours can be a general store or any other kind of store you care to letter on the windows. While I have stuck rather closely to the outline of the building and wings, I have cleaned things up a bit by making the three second-story windows to the right the same size and shape, narrowing down the dormer to give it a better propor-tion, increasing the number of panes in the large window on the right wing and increas-ing the size of the window in the end of that wing.

step 1. Paint Sky. When sky is dry, paint first wash of hills using raw umber, perma-nent blue, cobalt and Antwerp blue, leaving the white area for now.

step 2. Paint trees in hills using Indian red, burnt umber, burnt sienna, cadmium orange, Hooker's green, sepia, ultramarine blue and blend all together on paper.

step 3. Put in trunks of trees using sepia and alizarin crimson and ivory black for dark trunks. Place shadows on roof and side first wash.

step 4. Finish painting, saving detail for last. Intensify all dark values.

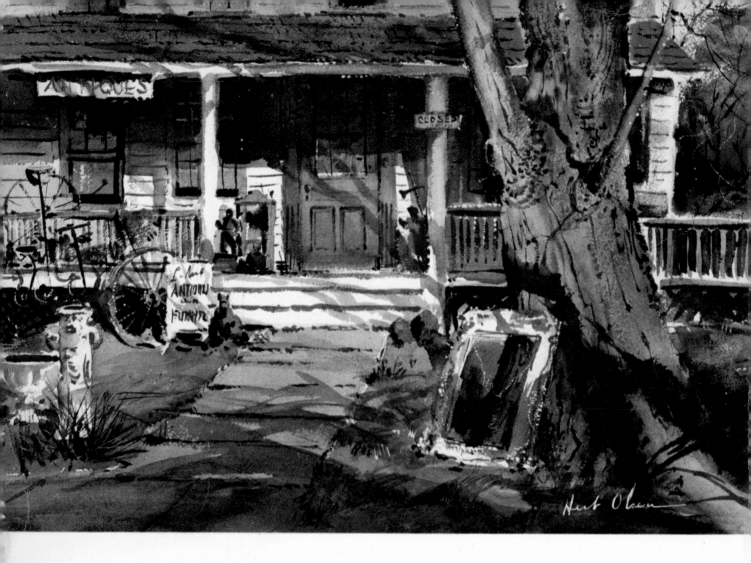

YESTERDAY'S TREASURES

In conclusion, the author wishes to express his appreciation to Gregory Dickson for his valuable assistance during the preparation of this book; for permission to use "3rd Avenue," from the collection of Mr. and Mrs. Rolf Klep and for permission to use "No Skating" from the collection of Mr. and Mrs. Daniel Prosnit.